Ron Terada

WHO I THINK I AM

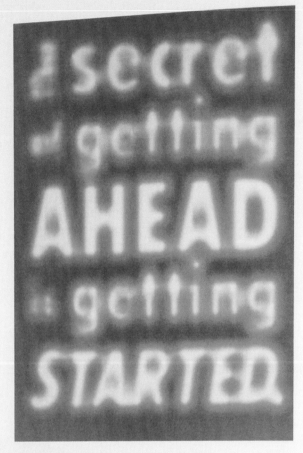

THE SECRET TO GETTING AHEAD IS GETTING STARTED, 1994,
C-PRINT, 40 x 29 INCHES
COURTESY OF THE ARTIST AND BLUM & POE, SANTA MONICA

Editor: Helen Legg
Assistance: Alex Lockett and Morgan Quaintance
Design: Derek Barnett for Information Office and Ron Terada
Photography: Scott Massey, Vancouver
Printing: CS Graphics Ltd, Singapore
Distributed in the UK by: Cornerhouse Publications
+44 (0)161 200 1503 www.cornerhouse.org

Ikon Gallery
1 Oozells Square, Brindleyplace, Birmingham, B1 2HS
www.ikon-gallery.co.uk
Registered charity no: 528892

Printed and bound in Singapore.

Who I Think I Am

Ron Terada

Edited by Helen Legg

PUBLISHED BY
IKON GALLERY, BIRMINGHAM
WALTER PHILLIPS GALLERY, THE BANFF CENTRE
JUSTINA M. BARNICKE GALLERY, TORONTO

This publication accompanies the exhibition *Ron Terada: Who I Think I Am*, presented at Ikon Gallery, Birmingham, 31 March – 16 May 2010, curated by Helen Legg, assisted by Alex Lockett and Morgan Quaintance; Walter Phillips Gallery, The Banff Centre, 15 May – 25 July 2010, curated by Kitty Scott, assisted by Naomi Potter; and Justina M. Barnicke Gallery, Hart House, University of Toronto, 12 January – 20 February 2011, curated by Barbara Fischer.

4

Ikon gratefully acknowledges financial assistance from Arts Council England and Birmingham City Council.

Justina M. Barnicke Gallery and Walter Phillips Gallery gratefully acknowledge assistance from the Canada Council for the Arts, Alberta Foundation for the Arts and Canadian Heritage.

British Library Cataloguing in Publication Data. A catalogue record for this book is available from the British Library.

CONTENTS

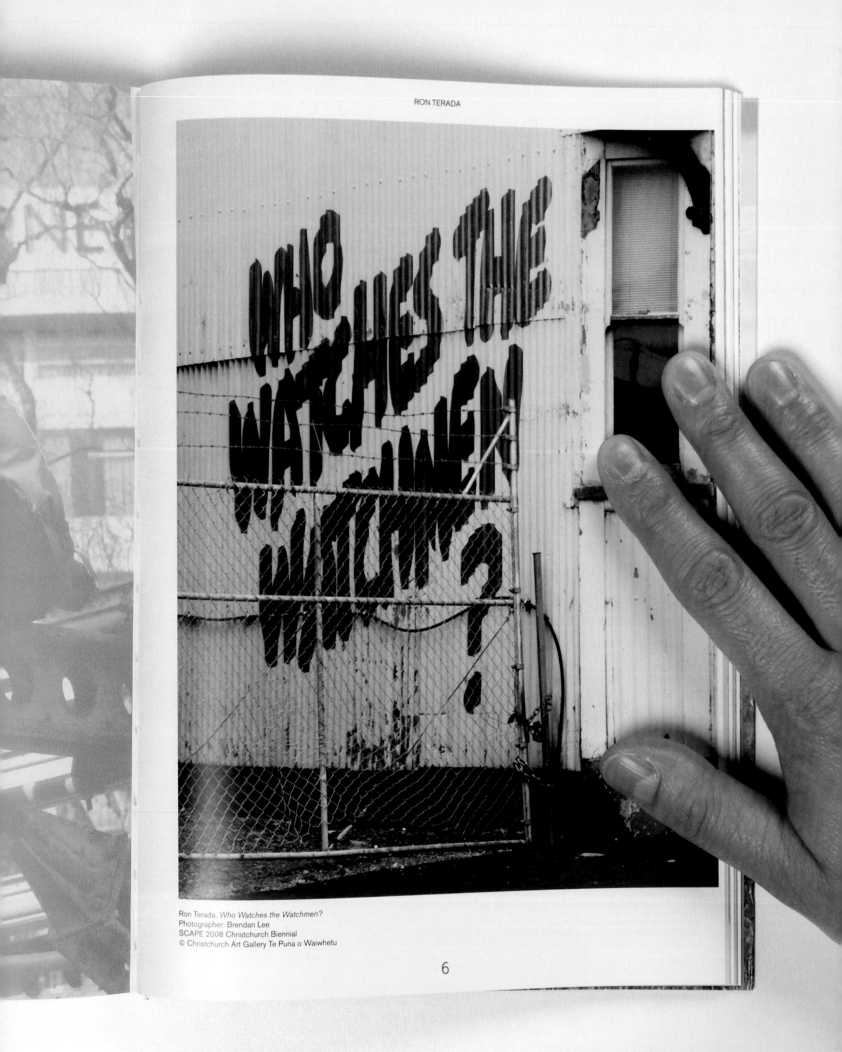

Ron Terada, *Who Watches the Watchmen?*
Photographer: Brendan Lee
SCAPE 2008 Christchurch Biennial
© Christchurch Art Gallery Te Puna o Waiwhetu

Foreword

This is the most comprehensive exhibition to date of work by Ron Terada. Split three ways between collaborating institutions—Justina M. Barnicke Gallery, University of Toronto, Ikon, Birmingham and Walter Phillips Gallery, The Banff Centre—it suits well an artist whose work, fundamentally, is an acknowledgement of the existence of others. There's us and him, here now, but as well an infinity of human decisions and gestures made by others, consciously and subconsciously, that impinge on everything we think we know. We can thus dwell on the nature of the art world within wider cultural contexts, as it is, after all, where we are, but Terada is encouraging us to generalise. His work is about the small differences that we all make, in any situation, simply by being alive.

Terada is wonderfully vital, curious, skeptical and amused. Other people? Well, they can be hell. Alternatively, they can inspire thoughts and feelings that would never otherwise have occurred to us. The appropriation we see here, of other people's text, of other people's design, of other people's music, is not the result of some slack, dead-end postmodernism, but rather the outcome of a rare sensitivity and openness. It is openness to bad

politics as well as to good things, to melancholia and desperation as well as to moments of pure happiness. Terada's work is thus a (very transparent) medium through which he conveys that which seems especially poignant. It could not be more about him, but could not be less autobiographical, and vice versa.

In this vein, the most recent work here, the series of *Jack* paintings, is extraordinary. It is as excruciating to read as it is cool in its treatment, painted and not really painted, funny, pathetic and ringing true terribly as the outpourings of a doomed man. The unedited transcription of the memoir of Jack Goldstein, an American artist who committed suicide in 2003, it embodies at once a vanity and emotional weakness we easily recognize. In ourselves and others. It is so much more than a cautionary tale.

The title of this exhibition, *Who I Think I Am*, refers to a personal identity that cannot be self-contained and discrete. On the other hand, it is not without integrity. Its no-nonsense proposition is the best any of us can hope for in the flux that passes as human life, impressive as an existentialist project. The fact that we could join in is at once a privilege and perfectly appropriate.

And there are yet more others. In particular we take this opportunity to thank those individuals and museums that have generously lent work. Catriona Jeffries Gallery, Vancouver, likewise has been unstinting. We are indebted to The Canada Council for the Arts, The Alberta Foundation for the Arts and the Paul D. Fleck Fellowship at The Banff Centre for invaluable support. Thanks to the writers herein, Anne Low, Cliff Lauson and Tom McDonough, for their enthusiasm and insights, and to Derek Barnett, our designer on this occasion. Members of staff at all three institutions have been typically committed beyond the call of duty, most notably at Ikon, Helen Legg (Curator), with Morgan Quaintance (Inspire Student) and Alex Lockett (Programme Assistant); at the Justina M. Barnicke Gallery, Katie Bethune Leamen (Exhibition Coordinator) and Christopher Regimbal (Curatorial Assistant); at Walter Phillips Gallery, Naomi Potter (Curator), Stephanie Kolla (Curatorial Assistant), Tabitha Minns (Gallery Program Assistant) and Mimmo Maiolo (Preparator).

Above all, we are grateful to Ron Terada.

Barbara Fischer
Executive Director/Chief Curator
Justina M. Barnicke Gallery, Hart House,
University of Toronto

Kitty Scott
Director, Visual Arts
Creative Residencies
Walter Phillips Gallery
Banff International Curatorial Institute

Jonathan Watkins
Director
Ikon

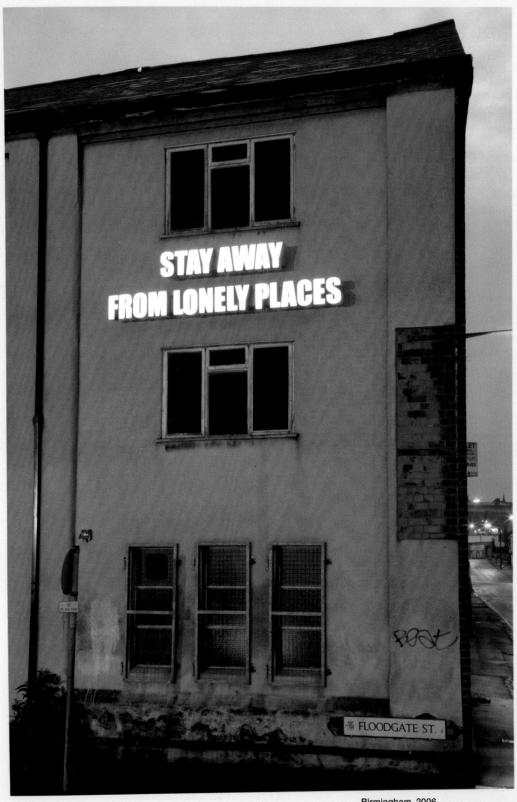

Birmingham, 2006
Ron Terada

catalogue or exhibi-
influence back to
ationist move-
bscribe to the
ideas are in every-
they'll come
ook, Mark Francis
pean artists—
odthaers, Art &
nd Jamie Reid—
uationist project.
also been felt in
tural practice in
in the 1970s and
did not necessar-
s nor had neces-
s. Without in any
North American)
, it can still be
can perspective)
ontation with the
way of the
in a large and
work. In the
e architectural
atta-Clark (fig.
ess of Dan
nema projects
racter. More re-
ormances have
owness of
content. Jenny
s, plaques, and
y mimic and un-
blic address
ko's projections

1.8
Ron Terada
You Have Left the American Sector, 2006
Musée d'art contemporain de Montréal

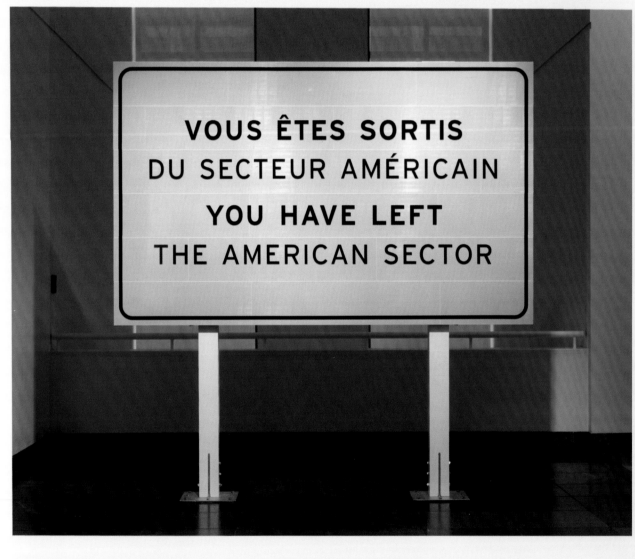

1.8
Ron Terada
You Have Left the American Sector, 2006
Musée d'art contemporain de Montréal

Exhibition Itinerary

Ikon Gallery, Birmingham
31 March - 16 May 2010

Walter Phillips Gallery, Banff
15 May - 25 July 2010

Justina M. Barnicke Gallery, Toronto
Hart House, University of Toronto
12 January - 20 February 2011

A PINK ELEPHANT AND
a GREEN KANGAROO AND
Two yellow SNakes
STROLLED up TO THE
BAR : "you're HERE
A LITTLE EARLY BOYS"
SAID THE BARTENDER,
"HE ain't HERE yet."

Untitled, 1987
Ink and graphite on paper, 9 x 12 (22.9 x 30.5)
Barbara Gladstone Gallery, New York

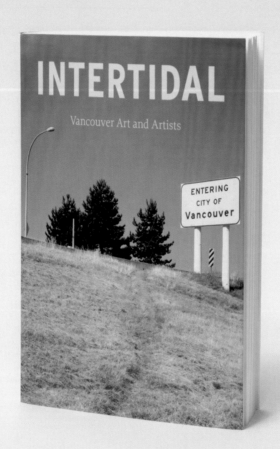

Entering City of Vancouver, 2006

THE IDEA OF A VANCOUVER ARTIST

Cliff Lauson

An artist with the need to create original and radical works must first get sick and tired of all the work he sees. Only then is he left with a clear field to look into…

Manifesto of 'IT', an anonymous art group, Vancouver, B.C., c. 1966[1]

… and the further north we went, the more monotonous it became.

Marianne Schroeder, Prologue from *The Idea of North*, Glenn Gould, 1967[2]

In the jointly authored project and book, *Learning from Las Vegas* (1972), the 'City of Lights' is subjected to an intense rhetorical analysis. Robert Venturi, Denise Scott Brown and Steven Izenour pull apart the multiple layers of symbols and signs that give definition to, and in turn are defined by, the city's spatial arrangement along the axis of The Strip. Las Vegas is designed to be encountered from a car rented at the airport. Its monumental thematic buildings are surrounded by moats of parking spaces, forming a chaotic and frenetic skyline that disrupts the otherwise flat surrounding desert horizon. As a backdrop, however, the hotels and casinos rise up behind a tangled mess of billboards, shaped neon signs and flashing advertising banners, all oriented toward The Strip. All are designed to be viewed while driving and all have evolved through competition, like a kind of post-modern natural selection, to match both the distance and the speed of the vehicular encounter. Numerous charts in the book describe the increasing size of logos and signs as a function of the speed and proximity of perception – ranging from the eastern bazaar to the high street to the strip mall – until they actually overtake and become themselves a kind of symbolic architecture.

While originating in an architectural context, *Learning from Las Vegas* has much in common with the pop and conceptual art interest in photography and vernacular signage. At times

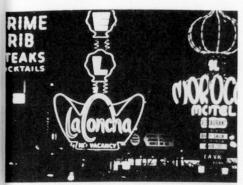

6. Night messages, Las Vegas

7. Allan D'Arcangelo, *The Trip*

DIRECTIONAL SPACE

	SPACE · SCALE	SPEED	SYMBOL sign-symbol · bldg ratio
EASTERN BAZAAR		3 M.P.H.	
MEDIEVAL STREET		3 M.P.H.	
MAIN STREET		3 M.P.H. 20 M.P.H.	
COMMERCIAL STRIP		35 M.P.H.	
THE STRIP		35 M.P.H.	
SHOPPING CENTER		3 M.P.H. 50 M.P.H.	

8. A comparative analysis of directional spaces

9. Parking lot of a suburban supermarket

this connection is made explicit, such as when the authors claim to make a number of 'Edward Ruscha elevations' of The Strip.[3] In general terms, as Hal Foster has noted, these disciplines intersect across 'cultural space entailed by consumer capitalism, in which structure, surface and sign often appear mixed.'[4] Located at this intersection is the work of Ron Terada, who examines the relationship between the spatial and social fabric of the city, in particular as it is manifest in the language of found signage. His work finds parallels with 1960s conceptual practices such as Ed Ruscha's use of photography and, in terms of language and signs, with works by Robert Barry, John Baldessari and Joseph Kosuth. Terada's ongoing interest in photographing, producing and manipulating public signage shows his concern with the way in which context and location are defined and reveals the possibilities for their redefinition. One of the most significant locations for his practice is the city of Vancouver, the place where he lives and works, and this essay follows Terada's negotiation of this 'theme' over the past decade. In many ways, this has less to do with the city itself than it does with the assumptions, perceptions and expectations of its artistic milieu brought by outsiders. An examination of this major strand of Terada's work is therefore equally concerned with the geographically focused exhibitions for which they were created.

It is by way of being relocated that Terada's pair of unassuming photographs of street signage, *Learn Photoshop* and *Learn Video Editing* (both 2004), gained critical agency within a recent exhibition of Vancouver-based art. These two modestly-sized 'sketches' (as the artist calls them) show a man patrolling a New York intersection with an advertising board protruding out of his backpack. Targeted at passing pedestrians, the sign is human scale, recalling the eastern bazaar from the Learning from Las Vegas diagram. The exhibition was *Intertidal: Vancouver Art and Artists*, a large-scale survey that included art produced in the city by a selection of artists since the 1960s.[5] Terada's two prints were surrounded by the work of artists comprising the so-called 'Vancouver School', not a grouping in any official sense, but rather a shorthand moniker for a generation or two of artists known for their modernist, tableau-sized photographs and filmic installations. At its centre this group usually includes some combination of Ian Wallace, Jeff Wall, Rodney Graham, Ken Lum, Stan Douglas and Roy Arden, with the occasional addition of other artists. In writings on these artists, the hybridised terms 'photo-conceptual

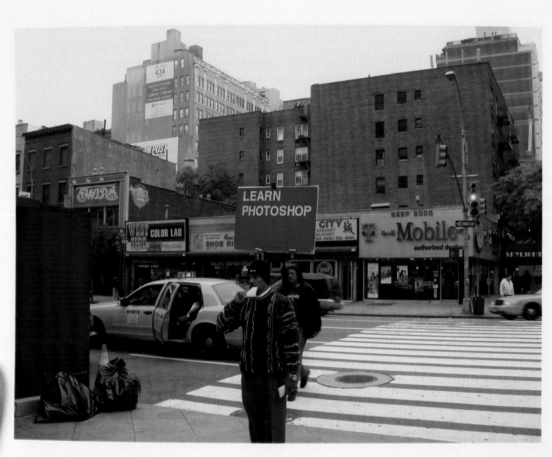

9.1.1.1. — *Learn Photoshop*, and *Learn Video Editing*, 2004, c-print, 10 x 13 inches

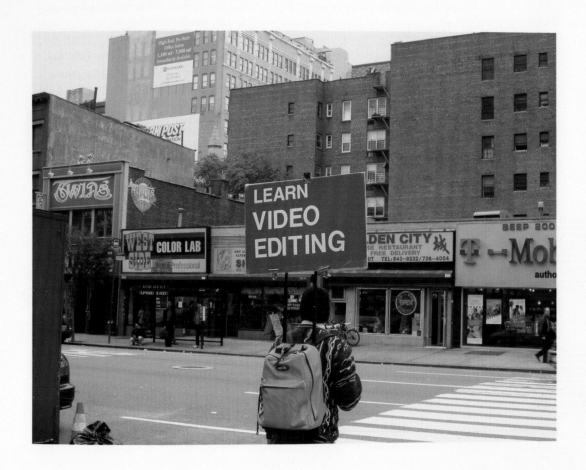

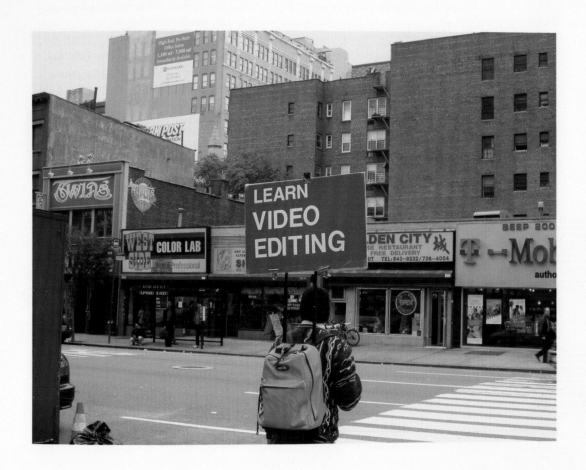

art' or 'photoconceptualism' usually follow quickly behind.[6] Terada's «Learn Photoshop» and «Learn Video Editing» thus took aim at the techniques of computer-assisted manipulation used to produce the highly finished appearance of their works. As two modestly sized digital c-prints – spontaneously snapped with a consumer-grade digital camera as opposed to a professional DSLR – Terada's photographs also countered the contemplative experience demanded by large scale photography, as inherited from the tradition of modernist painting. His prints seemed both diminutive and deskilled in comparison, implicating a different trajectory of picture making, more conceptual than modernist, more Ruscha than Manet. Terada's critique could also be said to run even deeper to the artists themselves, who frequently make use of studio assistants to carry out the laborious and time-consuming digital editing processes. However, this commentary is ironic as Terada, far from being an atelier artist himself, outsources some of the photographic and more technical aspects of his production to the wealth of expertise that surrounds him. 'In Vancouver, if you look under a rock,' jokes the artist, 'there are ten photographers.'[7]

While «Learn Photoshop» and «Learn Video Editing» carried very specific connotations in the context of a Vancouver-art exhibition abroad, their meaning changed when deployed in a more localised situation. When restaged the following year as billboard signage for the exhibition «Territory» – as the words 'Learn Photoshop' and 'Learn Video Editing' in changeable-lettering signboards on the grounds of Presentation House Gallery in North Vancouver – local residents constantly phoned the gallery to enrol in the non-existent classes. Here, these phrases attracted a more favourable response in the community oriented neighbourhood of a wealthy Vancouver suburb than they were likely

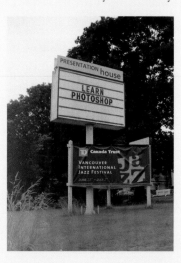

RON TERADA. *Learn Photoshop*, 2006

RON TERADA. *Universal Pictures 3*, 2001

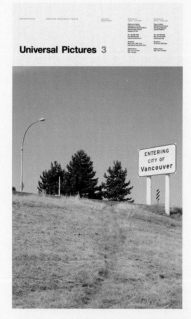

to do sticking out of the backpack of a man paid to patrol a busy New York intersection.

While being organised around the idea of a geographic centre, the «Intertidal» exhibition attempted to balance its curatorial thesis on the one hand, while on the other, avoid the reduction of the artists' work to geographic essentialism. For most of the artists in the exhibition, Vancouver is the place in which they live and work, and the city or its surrounding natural environs occasionally appear in their artworks; none of them however would champion the idea of being typical of 'Vancouver art'. Terada directly addresses this tension between biography and psycho-geography in his series of signage works, «Entering City of Vancouver» (2001–). Of these, his 2002 life size highway sign is best known, being the work with the greatest visual impact and the one most frequently used to illustrate his practice. However, it is really the entire series taken as a whole, its conceptual conceit through repetition and variation, that evidences Terada's ongoing concern with place and specifically with Vancouver.

The first version of the sign is a photograph that was designed to be used as the poster for «Universal Pictures 3», an exhibition held at the Blackwood Gallery, Mississauga in 2001. As indicated by the title, which plays on the naming convention of the movie sequel format, this was actually the third iteration of the exhibition to include Terada and two of his Vancouver-based peers, Geoffrey Farmer and Myfanway MacLeod.

All three had also been included in the earlier 1998 exhibition *6: New Vancouver Modern* which had proved something of a launching pad for them and the other artists involved.[8] Organised around a cinematic theme, Universal Pictures 'took the show on the road', beginning at the Melbourne International Biennial, then returning to Vancouver before moving on to Mississauga and finally to Winnipeg. Perhaps a nod to the idea of a road trip, and definitely combining his interest in the supplementary material that usually accompanies an exhibition, Terada's contribution to *Universal Pictures 3* was the highway poster that doubled as the interpretation leaflet.[9]

On the poster's front side the generic black and white wooden sign appears raised up on an embankment, adjacent to the highway shoulder barrier. The picture is taken from well below the eye-line of the sign, not at the angle it is intended to be encountered (from a car at speed), but from the bottom of a ragged footpath hewn out of the wild grass. Beyond the highway, three coniferous trees stand in the background, both ubiquitous signifiers of nature and the thematic of a number of works by 'Vancouver School' artists. The somewhat awkward viewing angle and distance to the sign give it a predominance over the 'landscape' and this unaesthetic site is also typical of a number of works by those artists that depict the transformative effects of modernity—the city's forgotten, transitory, and unidealised spaces. For example, Jeff Wall's *The Storyteller* (1986) takes place underneath a highway overpass and his *The Crooked Path* (1991) is located in an area of light industry. Similarly, Roy Arden's *Terminal City* (1999) is a series of photographs taken along a disused railway line that runs through the back of a Vancouver neighbourhood to the outskirts of the city. Terada's sign is thus not only a fitting readymade introduction to the location of the geographically organised exhibition, but also appears to represent a few of the shared themes of the so-called local movement. If the definition or even precise grouping of artists comprising the 'Vancouver School' is unclear, then Terada is happy to generalise in order 'to call attention to how Vancouver artists are identified in terms of a local brand for the purposes of commerce and publicity.'[10] The reverse side of the *Universal Pictures 3* poster contains the curators' essays and also a photograph of a different Vancouver sign, one with a more friendly civic character. Shaped out of wood and topped with the city's logo, this sign welcomes motorists rather than simply demarcating the city limits.

A year later Terada redeployed the same photograph as an advertisement in the pages of *Artforum* for the group exhibition *Signage* at the Catriona Jeffries Gallery. The overlaid type was replaced with the new title headings and the image was cropped to fit the magazine's square page format.[11] By embedding himself in the machinations that surround the production and

Jeff Wall, *The Crooked Path*, 1991, transparency in lightbox
119 x 149 cm
Courtesy of the artist

8. *6: New Vancouver Modern* was curated by Scott Watson and took place at the Morris and Helen Belkin Art Gallery, Vancouver, 6 February – 30 March 1998. Artists included Damian Moppett, Steven Shearer, and Kelly Wood.

9. Also playing to the idea of a road trip, Terada gave away *Soundtrack for an Exhibition* (2000-1) CDs at the last two venues of the exhibition.

10. Melanie O'Brian, 'Introduction: Specious Speculation', *Vancouver Art & Economies*, ed. Melanie O'Brian, Arsenal Pulp Press and Artspeak, Vancouver, 2007, p. 22.

11. See *Artforum*, June 2002, p. 95.

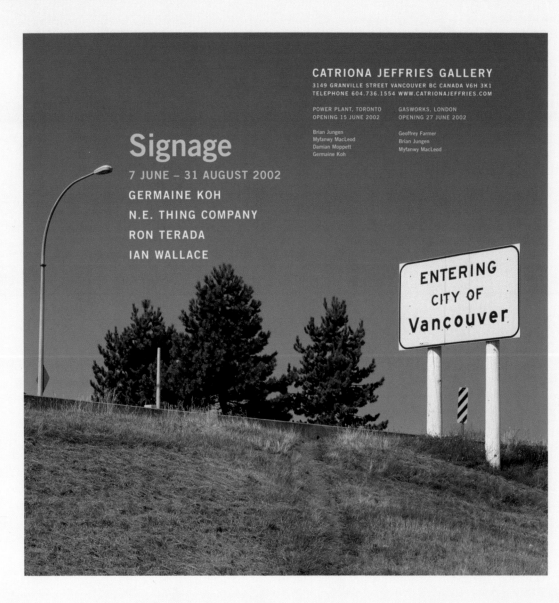

Signage

7 JUNE – 31 AUGUST 2002

GERMAINE KOH

N.E. THING COMPANY

RON TERADA

IAN WALLACE

CATRIONA JEFFRIES GALLERY
3149 GRANVILLE STREET VANCOUVER BC CANADA V6H 3K1
TELEPHONE 604.736.1554 WWW.CATRIONAJEFFRIES.COM

POWER PLANT, TORONTO GASWORKS, LONDON
OPENING 15 JUNE 2002 OPENING 27 JUNE 2002

Brian Jungen Geoffrey Farmer
Myfanwy MacLeod Brian Jungen
Damian Moppett Myfanwy MacLeod
Germaine Koh

circulation of art, Terada moved even further from an object-based practice. Addressing the fact that the exhibition is a group show in the commercial gallery that represents him, Terada evacuates the unique artwork from the production and sales cycle, effectively short-circuiting the system to convert the advertisement directly into the purchasable object. Thus, a framed print of the advertisement became his contribution to the show. This magazine work set the stage for Terada's extensions of its two conceptual directions the following year: firstly, by staging an entirely objectless exhibition, *Catalogue*, and secondly, by creating a single issue magazine *Defile*, consisting entirely of ads swapped with other art magazines.

Examining the details of the *Signage* advertisement, it becomes clear that Terada's play on Vancouver based groupings also applies to this show since it includes N.E. Thing Co. and Ian Wallace, two hugely influential figures for Vancouver art, both of whom contributed to the reputation of photo-conceptual art in the city. Terada's appearance amongst and alongside these artists is thus as complicit as it is sceptical, as accepting of this lineage as it is refusing to become a part of it. However, it might also be noted that two more group exhibitions of younger artists staged in Toronto and London also appear on the same ad. All are represented by the Catriona Jeffries Gallery and all are Vancouver based. It is not surprising then that a casual remark made by a magazine writer has often been quoted in more serious considerations of Terada's generation: 'When you collect one of [Catriona Jeffries'] artists—say a Ron Terada or a Damian Moppett—you are ostensibly "collecting Vancouver"'.[12] As the repetition of these artists' names starts to become familiar from one show to the next (6: *New Vancouver Modern* and all four *Universal Pictures* exhibitions included[13]), the intertwining of their emerging careers with a geographically centred promotional discourse becomes obvious. Indeed, as former Power Plant curator

Ron Terada
Entering City of Vancouver, 2002

Philip Monk admits in his introduction to one of the other shows advertised alongside *Signage*, the triumph of these artists is undoubtedly a civic victory: 'from my position in Toronto, I concede and applaud their artists' success: Vancouver rules.'[14]

It is the fact that curators and writers have continued to respond to the city as much as to its artists, not only affirming the relationship between the two, but also articulating the latter through the legacy of the 'Vancouver School', that has made this line of investigation increasingly productive for Terada. In retrospect, something of a game based on the notion of authenticity had started to unfold over the past decade. Terada's work continues to be informed by and respond to its enthusiastic reception as artwork from Vancouver. For his 2002 solo exhibition at the Catriona Jeffries Gallery, he commissioned the City of Vancouver signage department to produce an actual highway sign. Instead of looking like the painted wood sign in the 2001 photograph, this new sign was fabricated to the current standard of public highway signage and features weather proof aluminium parts, highly reflective coatings, built-in halogen lights and white text on a green background. The sign was installed in the front of the gallery and set in its front window, projecting outwards toward the pedestrians and traffic of the busy urban corridor of Granville Street. Disproportionately floodlit for a window display and awkwardly oversized for the retail-designed window that framed it (a mismatch of speed and scale according to the Venturi chart), Terada's sign made explicit the overlay of geographic boundaries onto cultural ones.

Indeed, while Terada's 'message' is in many ways as clear as the typeface that comprises it, the historical trajectories and local narratives bound up in the sign are less obvious. Those familiar with Terada's work will have noted that it is a kind of readymade extension of his earlier paintings—the solid green serving as the monochromatic ground on top of which white lettering is set. But in addition to bearing some loose resemblance to his own earlier work, Terada's sign recalls a 1968 work by N.E. Thing Co. partners Ingrid and Iain Baxter, who were a part of the 'IT' group quoted in the epigraph above. *¼ Mile Landscape* operates in a similar conceptual vein to their expansive series of Aesthetically Claimed Things (ACTs) by turning a stretch of an existing landscape into an artwork through linguistic designation—by way of highway signage. Part land art and part dematerialised conceptual art, the work is intended to be stumbled upon while driving on the highway, far from any populated areas:

When driving along the highway the driver sees a sign that says,

YOU WILL SOON
PASS BY A ¼ MILE
N.E. THING CO.
LANDSCAPE.

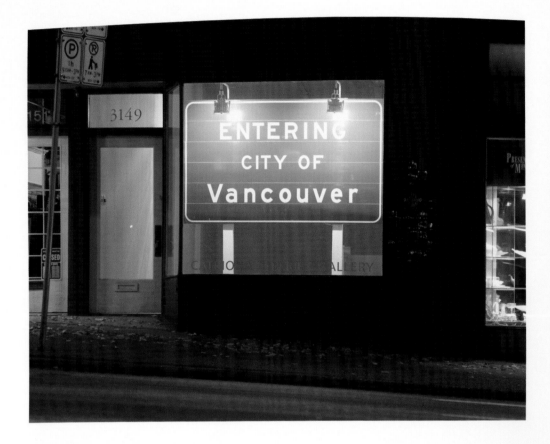

*Entering City of
Vancouver*
2002

Shortly he sees

<div align="center">

START

VIEWING,

</div>

and for the next ¼ mile he is driving alongside a ¼ mile designated 'N.E. Thing Co.
Landscape.'

The landscape is terminated when he sees

<div align="center">

STOP

VIEWING.

</div>

This ¼ mile landscape is in south California near Newport Harbour; another was done
in Prince Edward Island.[15]

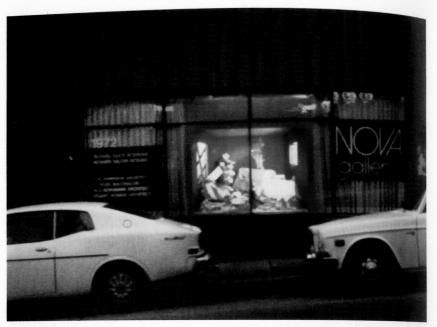

54 Jeff Wall, *Destroyed Room*, 1979. Cibachrome transparency, fluorescent lights, and display case, 159 × 234 cm. Original installation Vancouver, Nova Gallery (now Ottawa, National Gallery of Canada).

On the occasion of a 1992 survey exhibition of work by N.E. Thing Co., ¼ *Mile Landscape* was recreated on a stretch of road leading into the University of British Columbia campus. It was seen there by Terada on his frequent commute into the University where he was studying at the time. In retrospect, the work was influential on him, but it was not until the *Entering City of Vancouver* series of works that an opportunity emerged to re-engage with this historical precedent in which landscape, art and signage intersect. While N.E. Thing Co.'s signs impose artistic boundaries onto the geographic landscape, Terada folds geographic boundaries back onto the artistic landscape. It was of course through 1960s conceptual art and fluxus practices that peripheral cities such as Vancouver took on a new romantic spirit in the first place—a legacy that forty years later has become the subject of Terada's work.[16]

Yet another local reference for Terada's sign as it was first shown in the front window of the Catriona Jeffries Gallery was its uncanny resemblance to the installation of Jeff Wall's *The Destroyed Room* (1978) at the Nova Gallery twenty-four years earlier. The latter has come to represent a

ld act as a utopian prod
y. However, after circa
from challenge toward
ral trends, the utopian
disillusionment. This
t implosive force. The
econdition for the new
nscious but nonetheless
he central characteristic
at.

mploded utopianism of
In conceptual art the
social knowledge are
des are systematically
nimicry. In this sense,
ol-type 'Popism' in its
for control and falsifi-
e, whose despotic and
e art objects.

it their social subject-
t is considered to be a
t in the American sense
'over' (dissolved by the
moreover, that it was
produced by the clash
l ideas, 'Communism'
ype 'modernism' is the
of neo-capitalism, with
era of capitalist crises
supported private mo-
end of ideology'. The

seminal moment not only for Wall's career, being his first work in what would become his signature transparency in lightbox format, but also for Vancouver art in general. Wall's work portrays a staged scene of domestic mayhem, an overturned woman's bedroom. Roy Arden recalls that 'from a distance, it had the appearance of an advertisement, but there was no text and it didn't "read" from a distance the way bus-stop ads and billboards do.'[17] Using the front windows of their respective galleries, both Wall's and Terada's works' internal illumination projected beyond the shopfront window to attract the attention of passers-by. If this moment at the beginning of Wall's career has become something of a milestone for art made in Vancouver, then Terada's quotation of its form literally puts that boundary marker on display, as advertisement, as billboard. Just as the visibility of the studio at the edges of *The Destroyed Room* evidences the picture's staging and theatricality, Terada's work presents the city as a kind of mock tableau. It would however be a mistake to reduce Terada's work to simple parody as it maintains a critical relation to the commercial aspects of the private gallery space. Like Wall's work, it questions 'our relationship to commercial codes whose purpose principally is to sell goods, and to art objects, showing that they are both part of the same economic and semiotic representational system.'[18]

Entering City of Vancouver was subsequently included in *Baja to Vancouver* in 2003, an exhibition locating a north-south geographic tendency that crosses three countries along the West Coast of the Americas. In 2005, the curators of *Intertidal* used Terada's earlier 2001 photographic version as the cover image for the catalogue. The result was yet another rebranded permutation now with the exhibition's title in yellow lettering across the top of the photograph. Eager to perpetuate the continued framing and re-framing of Vancouver art, Terada then photographed the *Intertidal*

ISSUE NO. 96 $9.95

BorderCrossings

A MAGAZINE OF THE ARTS

STRANGE BEAUTY

Wim Delvoye
Guy Maddin
Erwin Redl
Steven Shearer

Art Green
Neil Farber
Lee Henderson

04

7 72006 86024 6

RON TERADA YOU HAVE LEFT THE AMERICAN SECTOR
22 SEPTEMBER – 28 SEPTEMBER 2005

ART GALLERY OF WINDSOR
401 Riverside Drive West
Windsor, Ontario
N9A 7J1 Canada

tel 519 977 0013
fax 519 977 0776
email@agw.ca
www.agw.ca

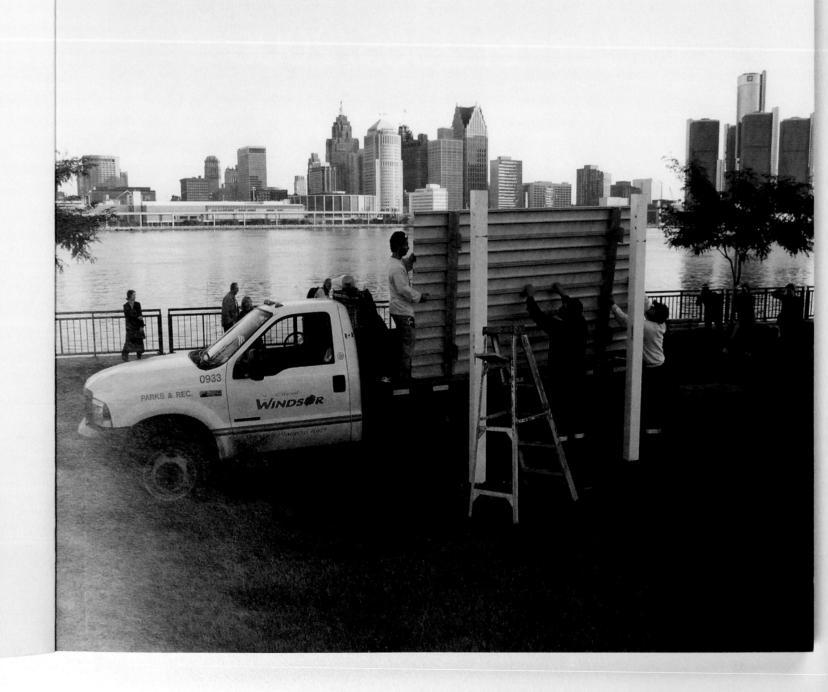

Still, not all of his research made it into the book. In editing the photographs down to twenty-six, he took out several that he felt were out of character with others in composition and design. In a photograph of a Union 76 gasoline station in Holbrook, Arizona, raking light casts long shadows that lend an uncharacteristic drama to the image (ill. 130). In another picture, deep muddy tire tracks in the foreground, coupled with a car on the road to the left, contribute a narrative to the piece. We read the image as if the photographer were approaching the station, rather than standing as a distant observer (ill. 131).

The first printing of *Twentysix Gasoline Stations* was for 400 numbered copies that sold for $3.00 each.[5] Ruscha's intention was to provide a book anyone could own for a modest cost. "I want to get the price down, so everyone can afford one," he once explained. "I want to be the Henry Ford of book making."[6] Ruscha's appreciation for handmade publications, like those produced by assemblage artist Wallace Berman, helped him clarify his goals. Unlike Berman's loose-leaf periodical of poems, drawings, photographs, and collages, titled *Semina* (1955–64; ill. 132), which had been manually printed in the artist's studio and distributed by mail, Ruscha set out to provide a product for mass consumption.[7] He thought of his books as "human size—portable friendly objects" and delighted in handling them and giving them away to fellow artists and friends (ill. 134).[8] By contemporary standards, the quality of *Twentysix Gasoline Stations* is unremarkable in every respect. As Ruscha said, I really wasn't interested in making a precious object. . . . I was interested in the idea of a mass-produced product.[9]

Critical response to *Twentysix Gasoline Stations* was mixed. Philip Leider, writing in the September 1963 issue of *Artforum*, placed the book in a Dada context:

Not quite a joke, the idea is too consistent, as the puns and issues posed by Duchamp. . . . we are irritated and annoyed by the act, yet we feel compelled to resolve the questions it raises. The urinal resolved in favor of Duchamp; for Ruscha and the movement he represents, the issue is still in doubt.[10]

In addition to its content, the book's small scale and unembellished presentation were perplexing to some and unimpressive to others. On October 2, 1963,

catalogue to create «Entering City of Vancouver» (2006). The monochromatic look of the inkjet print gives the image an historical or archival quality, to a degree dating the narrative of both book and exhibition.

Terada's more recent works have expanded his interest in the politics of place to encompass broader regions. «You Have Left the American Sector» (2005) is a highway sign fabricated similarly to «Entering City of Vancouver». Installed near one of the busiest Canada/US border crossings between Windsor and Detroit, this sign did not so much welcome drivers to the north as inform them of their place of departure. It quoted the famous Cold War Checkpoint Charlie sign and was slightly amended to include a French translation of the statement as per Canada's official bilingual policy. Terada's sign implied a crossing into hostile territory which was of course an over-exaggeration, but its subsequent removal did in fact point to latent economic and political tensions between the two countries.[19] Windsor officials removed the sign without consultation after only five days of display, fearing that a negative American response would damage the local economy. A photograph of the sign's deinstallation was subsequently used by Terada to create an advertisement in a Canadian magazine fittingly titled «Border Crossings».[20] Much like Ruscha's «Rejected» (1964), an «Artforum» 'ad' showing his «Twenty Six Gasoline Stations» (1963) that had been rejected from the Library of Congress, Terada's also included the truncated dates of exhibition as an historical record of the failed event.

Another signage work by the artist that demarcates the social construction of an even broader geographic boundary is «The Idea of North» (2007), a work commissioned for a Berlin exhibition of the same name. This was not the first time that Terada had returned the title of the exhibition as his contribution in the form of a sign.[21] This time, however, he played specifically on the rustic clichés of the northern wilderness, chiselling the title on a piece of driftwood and planting it in a metal bucket with fresh soil. Returning to the more modest pedestrianised categories of Venturi's and Brown's chart, this is the kind of sign one might find along a coastal walk on a long hike. The title «The Idea of North» refers to a radio play by Canadian mid-century pianist and presenter, Glenn Gould. Although Gould worked with a variety of 'real northerners' in the production, he also acknowledged the fictional aspect that arises when creating a location-driven narrative: 'though technically a documentary, [The Idea of North] is at the very least a documentary which thinks of itself as a drama'.[22] Hence Gould's

qualifying noun 'the idea of' – or equally, the notion or construction of – the north which attests to the issues at stake in constructing a psycho-geography. Terada's work shares this concern with distance, in both the physical and conceptual sense, holding that 'north is an idea as much as any physical region that can be mapped and measured for nordicity.'[23] For the Berlin exhibition, he contributed a photograph of «The Idea of North» sign rather than the sign itself, signalling his distance from the auratic artwork and from an authentic northern zeitgeist.

Working in the wake of the 'Vancouver School' artists, it is their legacy that Terada contends with, but also chooses to address. He could easily, like the majority of Vancouver artists of his generation, avoid or ignore the legacy of the so-called School, but what separates his work from that of his peers is his sustained engagement with the effects that this legacy generates in relation to his own work. The idea of a Vancouver artist is based on perceptions and stereotypes imposed from the outside, but also at times encouraged from within. Vancouver has become a place with a specific geographic and artistic reputation that precedes it. Like Las Vegas, Vancouver has acquired a «genius-loci», and Terada's work responds to the expectations of what a Vancouver based artist could be, should be, and sometimes is.

NOTES

1 «Vancouver, B.C.: Founding of 'IT,' an anonymous art group (1966)», *Six Years: The Dematerialization of the Art Object from 1966 to 1972*, ed. Lucy R. Lippard, Praeger, New York 1973, p. 12.

2 Glenn Gould, «Prologue From 'The Idea of North' (1967)», *The Glenn Gould Reader*, ed. Tim Page, Faber and Faber, London 1984, p. 389.

3 «Ruscha made one of the Sunset Strip. We imitated his for the Las Vegas Strip». Robert Venturi, Denise Scott Brown and Steven Izenour, *Learning from Las Vegas*, MIT Press, London 1972, pp. 26-29. This caption is followed by a series of montage panorama photographs of The Strip. These use a frontal style of photography mimicking Ruscha's *Every Building on Sunset Strip* (1966) which he ironically copied from architectural elevations in the first place in order to avoid the conventions of art photography.

4 Hal Foster, «Image Building», *Artforum,* October 2004, p. 271.

5 Co-organised by the Museum van Hedendaagse Kunst, Antwerp and The Morris and Helen Belkin Art Gallery, Vancouver and presented at MuHKA from 17 December – 16 February 2006.

6 See Chapter 1 of my unpublished doctoral thesis *In Vancouver as Elsewhere: Modernism and the So-Called 'Vancouver School'*, University College

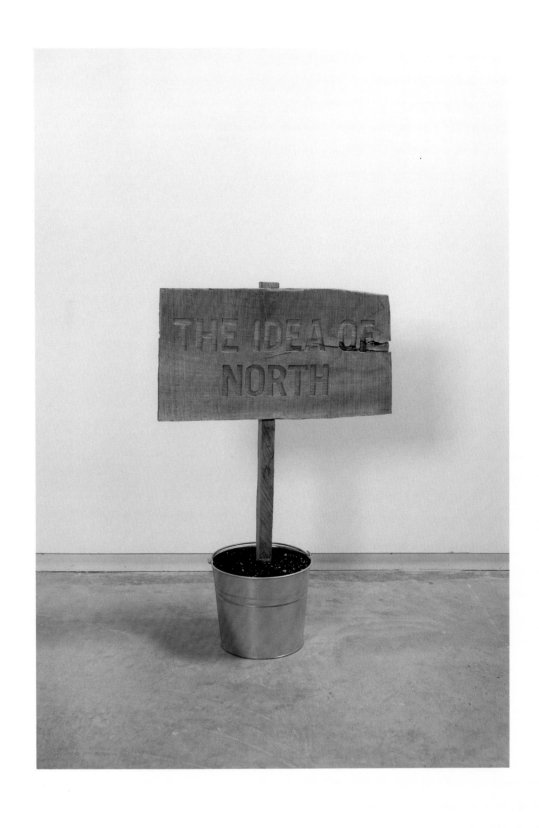

London, 2009, and Ian Wallace, 'Photoconceptual Art in Vancouver', *Thirteen Essays on Photography*, ed. Raymonde April, Canadian Museum of Contemporary Photography, Ottawa, 1990, pp. 94-112.

7. 'Ron Terada in conversation with Adam Brown, Annie Dunning, Robert Enright, Kristan Hortan, and Kerri Reid', unpublished interview, 2005.

8. *6: New Vancouver Modern* was curated by Scott Watson and took place at the Morris and Helen Belkin Art Gallery, Vancouver, 6 February – 30 March 1998. Artists included Damian Moppett, Steven Shearer, and Kelly Wood.

9. Also playing to the idea of a road trip, Terada gave away *Soundtrack for an Exhibition* (2000-1) CDs at the last two venues of the exhibition.

10. Melanie O'Brian, 'Introduction: Specious Speculation', *Vancouver Art & Economies*, ed. Melanie O'Brian, Arsenal Pulp Press and Artspeak, Vancouver, 2007, p. 22.

11. See *Artforum*, June 2002, p. 95.

12. Si si Penaloza, 'She's the One', *Canadian Art* (Spring 2003), 78. Subsequently quoted in Ralph Rugoff, 'Baja to Vancouver: The West Coast and Contemporary Art', *Baja to Vancouver: The West Coast and Contemporary Art* exh. cat., CCA Wattis Institute for Contemporary Arts, San Francisco, 2003, p. 19 and O'Brian, 'Introduction: Specious Speculation', p. 22.

13. One could also include *Hammertown* at The Fruitmarket Gallery, Edinburgh, 5 October – 23 November 2002, as contributing to this phenomenon.

14. Philip Monk, 'bounce', in *bounce / in through the out door* exh. cat., The Power Plant, Toronto, 2002, p. 5.

15. Marnie Fleming, 'Baxter and N.E. Thing Co., 1965-70', in *Baxter²: Any Choice Works* exh. cat., Art Gallery of Ontario, Toronto, 1982, p. 50. Also see *You Are Now in the Middle of a N.E. Thing Co. Landscape* exh.cat., UBC Fine Arts Gallery, Vancouver, 1993.

16. Specifically, in the late 1960s Vancouver's art scene attracted international attention culminating in Lucy Lippard choosing the city for her *995,000* exhibition in 1970. See Philip Leider, 'Vancouver: Scene with No Scene', *artscanada*, 24, no. 109-110 June 1967, pp. 1-8; David P. Silcox, 'The Canada Council', *Artforum*, 6, no. 2, October 1967, pp. 43-45; and Peter Selz and Alvin Balkind, 'Vancouver: Scene and Unscene, A Conceit in Eight Scenes and an Epilogue', *Art in America*, 58, no. 1 January/February 1970, 122-126. N.E. Thing Co. were also featured on the cover of the May/June 1969 issue of *Art in America*.

17. Roy Arden, 'Tabula Nova: A Personal Account of the NOVA Gallery', in *Real Pictures: Photographs from the Collection of Claudia Beck and Andrew Gruft* exh. cat., Vancouver Art Gallery, Vancouver, 2005, p. 126.

18. Dan Graham, 'The Destroyed Room of Jeff Wall (1980)', *Real Life Magazine: Selected Projects and Writings 1979-1994*, ed. Miriam Katzeff, Thomas Lawson and Susan Morgan, Primary Information, New York, 2006, p. 44.

Phillips Galle
Winnipeg Ar

26. Among
Tom Dean, A
Jana Sterbak,

27. This is n
and challenge
Douglas Gall

28. Some of
Rodney Grah

29. In 1989,
showed Joann
Grunt showe

30. *Parallelo*

19. For example, Canada had refused to join 'the coalition of the willing' US-led invasion of Iraq in 2003. Subsequently the permeability of its borders became the subject of intense scrutiny by US Homeland Security. Terada's work *Five Coloured Words in Neon* (2003) mimics the US Homeland Security Advisory System.

20. For an account of the Windsor sign controversy see Lee Rodney, 'Have you left the American Sector? Ron Terada's Adventure in the "City of Roses"', *Fuse Magazine*, 29, no. 2, April 2006, pp. 8-12.

21. Previous exhibitions in which Terada used this conceit include: *These Days* (Vancouver Art Gallery, 2001), *Promises* (Contemporary Art Gallery, Vancouver, 2001), *Sign Language* (Museum of Contemporary Art, Los Angeles, 2004), *Territory* (Presentation House Gallery, North Vancouver, 2006), *Concrete Language* (Contemporary Art Gallery, Vancouver, 2006) and *The Show Will Be Open When the Show Will Be Closed* (various locations, London, 2006).

22. Glenn Gould, '"The Idea of North": An Introduction (1967),' in *The Glenn Gould Reader*, ed. by Tim Page, (London: Faber and Faber, 1984), p. 392.

23. Sherrill E. Grace, *Canada and The Idea of North*, McGill-Queen's University Press, Montreal, 2001, p. xii.

3.10
Ron Terada
Catalogue, 2003
Courtesy the artist and Catriona Jeffries Gallery

(the ego,
was to con-
of the un-
realist notion
release of re-
ntionally
his displace-
hift in the
ous to con-
urrealist slo-
by the Enragés
r to the imagi-
⁵ The poetic
and vice
ousness.

e only chan-
reached the
rought with
heir own
fig. 3.10),
d dedicated
theorist. The
Jorn as by
group in
r criticized
e period of
th parties,
ighly politi-
paid a mov-
Jorn died in
074), a book
ad built in
time of

Anne Low

The Promise Without the Product

Other, 2006
C-print, 10 × 13 (25.4 × 33)

You're in a desert, walking along in the sand when all of a sudden you look down and you see a tortoise, it's crawling towards you…you reach down, you flip the tortoise over on his back…the tortoise lays on its back its belly baking in the hot sun beating its legs trying to turn itself over but it can't, not without your help, but you're not helping…I mean, you're not helping, why is that…?[1]

 In any city, one is constantly surrounded by the opportunity to read in the most literal sense: street names, traffic signs, posters, billboards, the illuminated names of restaurants and shops; text leans on sandwich boards, moves past on the sides of buses, lies on the ground in a discarded newspaper. The majority of these written words and numbers we recognise, rather than read, as we are able to register their forms through the style and structure of their delivery. However, every once in a while one's attention gets caught by something such as a spelling mistake, a font that seems incongruent with the words it spells or the curiousness of what a sign claims, my favourite recent sighting being: 'Same menu new chef', suggesting that similarly bad food would continue to be prepared, this time by someone different. Throughout his practice, Ron Terada has picked up on these discrepancies of how language and signage function as formal objects in space and his authorial style is constituted by a conflation of this standardised, familiar language with personal selections of cultural reference. This procedure allows Terada a level of invisibility with regard to his own relationship to the meaning created by his unlikely pairings, wherein existing visual material is imported and reconfigured to suit the artist's own subjectivity.

 Terada's *Voight Kampff* (2008), a visually lush and seductive video displayed across a bank of monitors accompanied by a series of large scale colour photographs, is the artist's first moving image work and has a dimension of stunning

Catalogue, 2003
Hardcover catalogue; 96 pages,
offset print on paper 11 × 8 (28 × 20.3)
Courtesy the artist and Catriona Jeffries Gallery

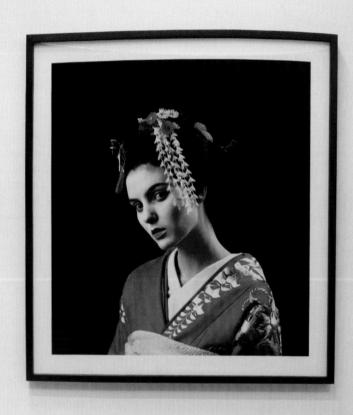

Maiko #1.

visual pleasure hitherto unseen in his practice. The work directly references, through both its title and subject, the 1982 film *Bladerunner*, Ridley Scott's dystopic, retro-fitted future prophesy for a Los Angeles of 2019. The use of a pre-existing structure of address in *Voight Kampff* (the electronic billboard) and choice of a subject taken from an external source that is then restyled through a process of extrapolation, is a technique at the heart of Terada's practice. Yet it is within *Voight Kampff* where Terada explicitly leads meaning away from its clearly identifiable origins into a charged arena of passive critique and provocation.

Within the complex visual universe of *Bladerunner*, we encounter a standardised test, the Voight Kampff test, which is used to detect – in the interest of retiring (or rather destroying) – highly functioning robots, 'replicants', that are developing their own emotions, contrary to their original design and have thus become a threat to the very integrity of human genetics. The test is designed to provoke an emotional response, measured through the quickening

of a heartbeat, the dilation of the pupils and other uncontrollable bodily responses. The moments Terada has appropriated from *Bladerunner* are relatively ephemeral within the visual narrative of the film, as both the video and photographs of *Voight Kampff* borrow a transitory image that first appears in the original film as an advertisement displayed on an electronic billboard on the façade of a skyscraper, and later, in more than one scene, on a screen affixed to a roving aircraft-cum-billboard. In the series of advertisements a geisha, whose alert but coy gaze is directed at the camera, smokes, takes a small pill and enacts mannered gestures of consumption. Extracting and re-staging this moment outside the context of the film, Terada has re-configured its presentation – which in the context of its first showing[2] was propositional as the work was conceived to be presented outside on an actual electronic billboard – into

The unicorn

a form that is at once a familiar monolith of pure advertising (a single image gridded across a bank of monitors) and a style of video display first proposed by early video artists such as Nam June Paik, for whom the mechanism of display became a conceptually and physically integral part of the work itself. Terada has destabilised the original image by re-casting the role of the geisha with three young Caucasian women who are dressed and made-up as maikos, 'geishas in training'. In a series of short takes the young women mime gestures (in the style of the geisha in *Bladerunner*) as they smoke, ingest pills and drink, their gazes addressing the camera and thus the viewer directly. The languid and seductive movements of their eyes, shoulders and posture in addition to their silent

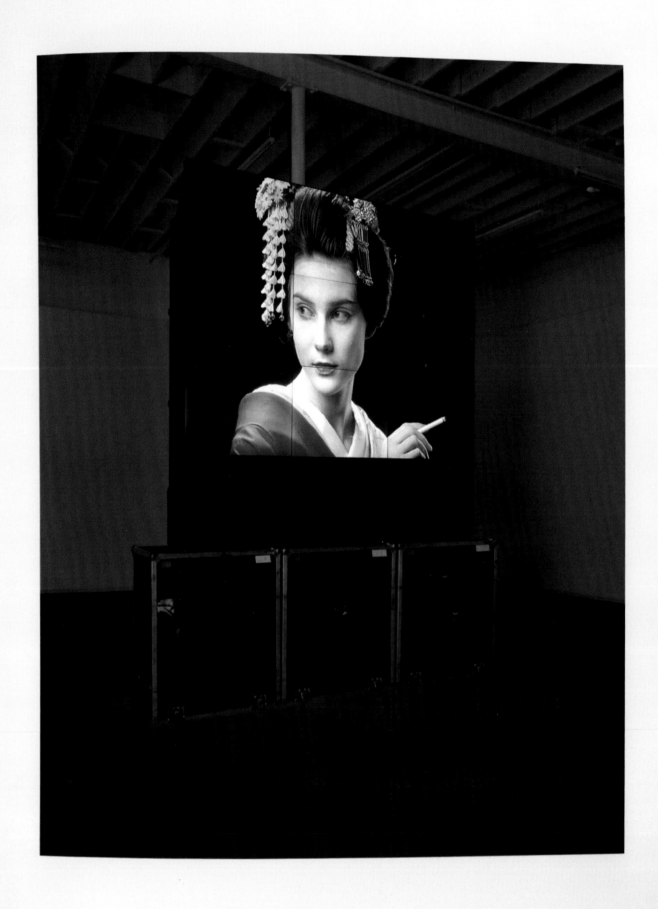

and suggestive gazes establish them as sites for the pure projection of desire, exaggerated by the fact that the scenes are devoid of any decipherable promotional product. The editing and framing of the scenes suggests that they could be out-takes or screen tests, moments enacted in front of the camera in practice or preparation for an advertisement.

Given his preoccupation with the language of address associated with advertising and signage it is perhaps unsurprising that the moments Terada selects from *Bladerunner* are those of transitory billboards glimpsed in passing. His focus on minute details such as these also articulates a changed relationship that artists and viewers alike now have with the moving image offered by developments in digital technology. DVD players and computers provide the opportunity of being able to slow down, speed up, repeat and pluck single frames from filmic narratives which has significantly shifted and reconstituted the pleasure of viewing to a space outside the cinema. As Laura Mulvey suggests in 'The Possessive Spectator,'[3] an illusion of possession has replaced the original gratification of watching movies, wherein pleasure was found in the loss of one's self-consciousness and ego, enveloped in the collective darkness of the cinema where desire was projected onto the characters on screen. This, however has now 'give[n] way to an alert scrutiny and scanning of the screen lying in wait to capture a favourite or hitherto unseen detail.'[4] The moment re-staged in *Voight Kampff* is very much such an unseen detail; it lies outside the narrative necessity of *Bladerunner*. By way of possessive spectatorship, Terada has 'unlock[ed] the film fragment (from linear narrative) and open[ed] it up to new kinds of relations and revelations.' Terada opens up these relations and revelations in ways that are wily provocative. For the artist, the moving picture of the geisha embedded within *Bladerunner*'s urban backdrop became a symbolic image associated with the future, with the look of a city of 2019. However, the subjects of the video and the photographs are also there to be *looked at* unabashedly, and their gestures assert that they are very much aware of this. The seductive

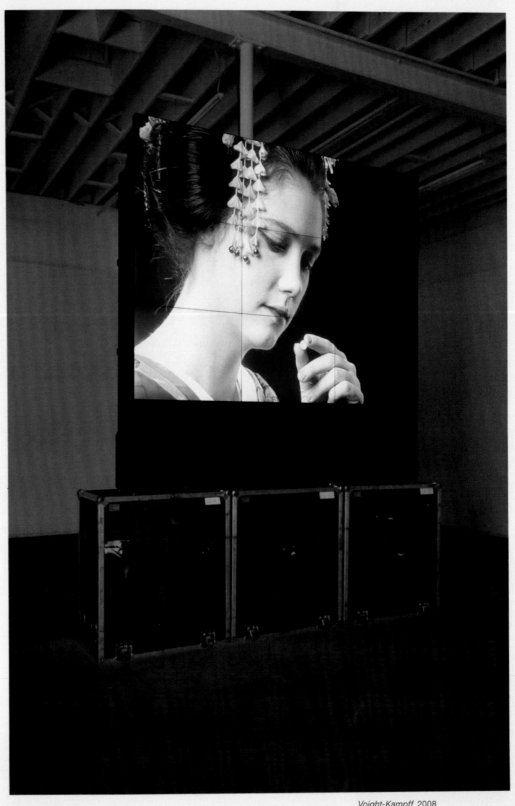

Voight-Kampff, 2008
Ron Terada

detail of their kimonos, hair and make-up is further amplified by the apparently disaffected pleasure they take in being watched as they engage in the consumption of substances that indicate a certain recklessness (if we are to assume the pill they are taking is a recreational drug and the liquid they sip is alcohol). To further complicate this restaging, the young women are not Japanese and this decision, in addition to their behaviour, suggests that they are dressed in this way less as authentic maiko but more as costume, playing on Western sexual clichés of eastern exoticism. Through his restaging, the suggestive gestures enacted in *Voight Kampff* are delivered in the heightened style of pure commodity – isolated moments truncated from a narrative that in actuality never existed – Terada has given it to us *without* any tangible commodity: the promise without the product. The gesture of appropriation that occurs in *Voight Kampff* is less a direct postmodern

reification of the innumerable images that lie dormant in wait in popular culture, but rather an extrapolation of reference into the realm of total fantasy. This is not the first time Terada has acknowledged *Bladerunner*; the cover of his 2003 exhibition catalogue, (titled *Catalogue*, this publication in fact constituted the work of the exhibition itself) bears an image of a silver origami unicorn which refers to the appearance of the mythological creature in a dream sequence experienced by Harrison Ford's character as well as a series of carefully placed origami creatures folded by the mysterious police officer who appears fleetingly in the film. For the artist these origami figures serve both to foreshadow narrative development and to provide symbolic cues about the nature of reality itself within the film; the photographic images in *Bladerunner* function in a similar way in that they appear to be genuine photographs of childhood memories, but are in fact decoys,

Rosemary's Baby, ROMAN POLANSKI ¬ 1968

43

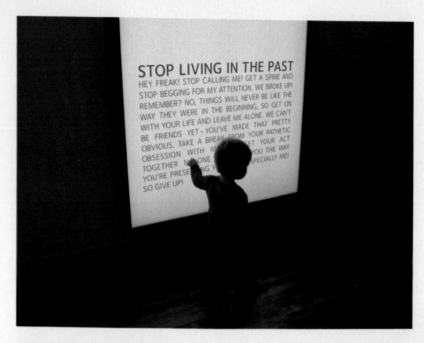

STOP LIVING IN THE PAST
2001/2003, Lightbox

dustriel-
Dabei
nheit,
atischen
Filmge-
deutung
techni-
hinein-
Natur.
Die
ste) in
ch diese
gsmäßige

schichte
blick auf
nzipiert
s wurde
Gold-
h aus der
wigung
auslösen
Bezug
rehen
den 1927
rwendet
bit (zu-
Califor-
seinen
sende
en, führ-
sen Auf-
ripts
nn seine
uf diese
pten zu
lurch
dee sei
e ähnli-
Falle des

manufactured for replicants to give a false sense of self and origins. For *Catalogue*, the sum of approximately $40,000 CDN was raised via private and corporate funding sources to produce an exhibition catalogue that for the artist, as paraphrased by Reid Shier (the exhibition's curator), would appear to be *inappropriate* for an artist of his reputation and stature. The accompanying exhibition consisted of all of the names of the donors listed on the walls within the gallery as well as the pages of the catalogue. Although *Catalogue* appeared to be a standard exhibition publication, Terada's objective was to create the book as the artwork in and of itself, to impart a level of authenticity to something that otherwise did not exist, thus revealing in a relatively neutral fashion the systems of exchange at work in the production of an exhibition and that which then represents it (the book) for perpetuity – thus provoking, as opposed to critiquing, discourse within the realm of institutional critique. The seemingly inexplicable image on the front of the catalogue of the origami unicorn and the artist's feet was in fact taken from an edition produced in order to attract donors to the project, which they received in exchange for their donation. It also functioned as a nod to the ostensible authenticity of the catalogue by creating a subtle mimicry where 'what you see isn't always what you get. It [the catalogue] mimics one, posing as a replicant of sorts.'[6]

Although *Voight Kampff* operates on an entirely different visual register from *Catalogue*, they are similar in that they are both composed not of a singular material gesture, but rather via the very particular styles and modes of address Terada adopts or evades, be they artistic or popular. These choices are extremely particular and consistent and throughout his practice more often than not contrast an emotional sentiment with a reductive and dry form of address associated with Conceptual art, which has now become a style in itself in the wake of the first generation of 60s and 70s Conceptual art, and its various 'neo' incarnations since. As Victor Burgin notes, 'in the early stages of conceptual art the machine printed photograph and typewritten text had offered, for a period a "zero degree" of style in which authorial expression could be subsumed to issues of content.'[7] With this, Burgin was condemning certain neo-conceptual practices of the 1980s 'as nothing but style, nothing but commodity', in the wake of first generation Conceptual art's failure as an avant-garde. Today contemporary artists are left with only the symbolic relics of Conceptual art reconstituted through a third, and perhaps final act. Terada has often communicated an emotional subjectivity through the borrowed language of Conceptual art, such as in the text-based lightbox works *Black and White* (2001), *Your Idea* (2001/2003) and *Stop Living in the Past* (2001/2003), all first-person monologues

44

Arena, 2001, video still

about romantic break-ups. Additionally, in *Soundtrack for an Exhibition*, Terada created a playlist of songs, all contemporary to the time, leaving the viewer the task of understanding the implicit meaning created through the lyrics and mood of the songs and their sequence, as any good playlist does. For its realization in 2000 at the Or Gallery in Vancouver, the playlist was displayed as a video in the form of rolling credits and was also conceived as an alternate soundtrack for *Bladerunner*, something the artist embedded obliquely within the playlist via the genre of music and particular song titles. It was also available as a CD that viewers were able to take away with them, thus allowing Terada's selection to become a soundtrack outside of the gallery for the viewer's own subjective narratives. As Terada continually uses that which already exists within culture as his material, *Soundtrack for an Exhibition* is potentially *altermodern* (to use Nicolas Bourriaud's recently coined term), in that it 'materialis[es] trajectories rather than destinations' by 'translat[ing] and transcod[ing] information from one format to another.'[8]

However these works, and particularly *Voight Kampff*, do not simply become the sum of their references. Aside from the means of style that Terada employs,

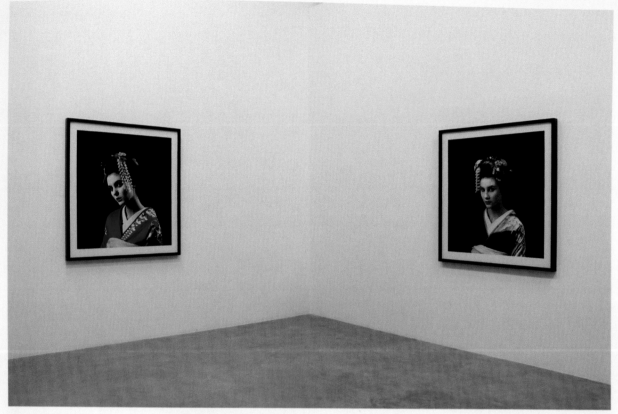

'MAIKO #1' & 'MAIKO #2'
INSTALLATION AT CATRIONA JEFFRIES GALLERY, VANCOUVER, 2008

what still begets consideration is the subject of the work at hand and the artist's relationship to it. Terada's position therefore is purposely *not* determined in relation to those references and the implications of their meaning. The complex matrix of reference and style that is at play in *Voight Kampff* is compelling in that an equation has been proposed and given a trajectory yet a determinable sum of those parts has not been given, they hang quizzically, inciting multiple answers – *Voight Kampff* goads a fetishistic scopophila[9] through the mute and consumable nature of the young womens' images as objectified other, while at the same time remaining deliberately reticent in its intended meaning. In this way, this work, and the artist as well, are provocatively *positionless*, provocatively *passive* in relation to the subject that is presented via the accumulation of reference. Similar to the soft institutional critique of *Catalogue*, wherein Terada revealed, but did not necessarily critique, the origins of funds that were procured for the production of his exhibition catalogue, they become, like the Voight Kampff test in *Bladerunner*, designed to provoke a response in the test subject (or rather the viewer). Like the anecdote of the turtle, flipped on its back, struggling to right itself, one is asked what one would do, how one would react, as correspondingly Terada makes propositional equations wherein the variable outcomes provoked by the work are myriad and the artist's authorial subjectivity as the maker of such works is displaced via a clever but inconspicuous transferral of liability of potential meanings onto the viewer.

9. A term used by Laura Mulvey in her feminist critique of narrative cinema, 'Visual Pleasure and Narrative Cinema' (1975), to describe the pleasure obtained in looking at another person as an erotic object.

1¬ A question posed as part of the 'Voight Kampff' test from Ridley Scott's 1982 film *Bladerunner*.

2¬ *Voight Kampff* was first shown at Catriona Jeffries Gallery in 2008.

3¬ Laura Mulvey, 'The Possessive Spectator', *Death 24 x a Second: Stillness and the Moving Image*, Reaktion Books, London, 2006, p. 163

4¬ Ibid, p. 164

5¬ Ibid, p. 165

6¬ A quote from Ron Terada from an email conversation with the author, November 2009.

7¬ Victor Burgin, 'Yes, Difference Again…', in Alexander Alberro & Blake Stimson (eds), *Conceptual Art: A Critical Anthology*, MIT Press, 2000, p. 429

8¬ Nicolas Bourriaud, 'Altermodern', *Altermodern*, Tate Publishing, London, 2009, p. 12

9¬ A term used by Laura Mulvey in her feminist critique of narrative cinema, 'Visual Pleasure and Narrative Cinema' (1975), to describe the pleasure obtained in looking at another person as an erotic object.

King of New York, Abel Ferrara ¬ 1990

Jack Goldstein und sein Hund Jack
Jack Goldstein and his dog Jack
(Foto / *photo*: Helene Winer)

PERSONALITY CRISIS

ON RON TERADA'S JACK PAINTINGS

Tom McDonough

The moment of Ron Terada's emergence as a young artist in the early 1990s corresponds rather precisely with that of Jack

Goldstein's disappearance. Goldstein (1945-2003) left New York in 1992, the year Terada abandoned his education at the University of British Columbia; as the latter embarked on his series of untitled *Ad Paintings* (1993-94, with a brief reprise in 1996), the former vanished from view, abandoning art-making and descending into heroin abuse, depression and abject poverty. Goldstein would spend much of the following decade living in an unheated trailer in East L.A., in and out of psychiatric treatment, for all intents and purposes lost to the view of an art scene that had hailed him as a pioneer of the appropriation-based strategies of the 1980s. 'His absence created a mythology around him,' his friend the curator Chrissie Iles wrote after his death, and that mythology persisted even after he reappeared around 2000, exhibiting new work and being the subject of an important retrospective.[1] Indeed, despite this renewed attention to his work, Goldstein committed suicide in 2003, soon after the completion of a memoir, co-written with Richard Hertz, which revisited the years between 1970 and 1990 as a generation of artists trained in CalArts' legendary post-studio program moved East and became

Jack Goldstein and the CalArts Mafia

by Richard Hertz

With reflections by

John Baldessari

Troy Brauntuch

Rosetta Brooks

Nancy Chunn

Meg Cranston

Jean Fisher

Hiro Kosaka

Robert Longo

Matt Mullican

James Welling

Tom Wudl

nexus of the art market, mimicking the appearance of these ads, which we should note are uniformly text only, anonymously designed, and whose dimensions are determined by the purchase price of a segment of page space (a logic repeated in his later *Catalogue* and *Defile* projects); second, that the ads he selected were generally not from contemporary issues of the magazine but from the later 1980s, that is, from a moment before the crash of the art market and the rather straightened circumstances of the early 1990s; third, that through his selection he assembles a pantheon of artists (Lucio Fontana, Donald Judd, On Kawara, Matt Mullican, Carl Ostendarp…) that simultaneously indexes a genealogy of his practice of painting and constitutes an all-male gathering of established talent with which he ironically associates himself; and lastly, that the choice of acrylic on canvas can only be seen as a perverse decision in the context of Vancouver's valorization of photoconceptualism, a clear refutation of the subtle intellectuality frequently associated with its artists at that time.[5] Terada's *Ad Paintings* already announce his parasitical relation to source material, his curious amalgamation of parodic distancing and implicit identification, and the adoption of mimicry as a central strategic device: 'the work moves beyond referencing advert-like material (to make paintings) to literally occupying the space of advertising (printed matter) *as the work*,' in his own account of this evolution.[6]

The *Jack* paintings seem to fuse the art world self-referentiality of the Ad works (and of the *Catalogue* project, for that matter) with the affective resonance of following series such as the *Personal Paintings* (1994–96) and the *Grey Paintings* (1996–97), which superimposed over monochrome grounds the text of personal ads and high school yearbook photo captions, respectively. In them we are caught between the reified language of late twentieth century life—a hollowing-out of the subject by the mechanisms of commodification—and the lingering, even atavistic, desire for recognition and self-expression. The texts operate in a register between the pathetic and the touching, once again conveying the artist's characteristic ambivalence. But more significant perhaps is the way in which these messages are materialised

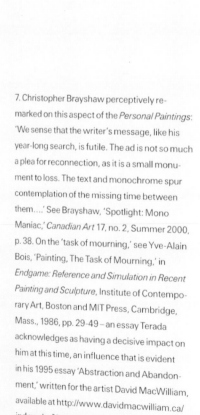

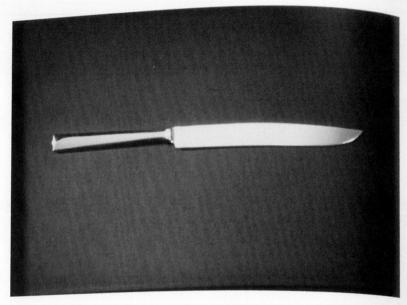

The Knife, 16mm, colour, silent, 4min, 1975, film still

LILY VAN... ...KKER

John Waters/Charles Esche

RON TERADA

Tom McDonough

in paint, and hence the way in which Terada plays off a history of the monochrome. This was a project already begun in the previous *Ad Paintings*, works that insisted that the monochrome was always in some essential sense defined by its institutional context (and hence works that conjoined the superficially distinct paradigms of monochrome and readymade), but becomes much more complex in the subsequent series. Both the *Personal Paintings* and the *Grey Paintings* explore a peculiar temporality of the artwork: they confuse present, past and future in a strange amalgam of desire and frustration. The personal ads, for example, overlay a present state of lack with an unfulfilled past ('I saw you…') and an ever-deferred future ('Phone me…'). In their deployment of the desperate tones of the anonymous composers of the advertisements, the paintings are witty commentaries on what has been called contemporary abstract painting's 'task of mourning,' which has now been brought down to the quotidian level of the lovelorn.[7]

Many commentators have sought to place these works within a lineage of text-based painting, with particular reference to Ed Ruscha and John Baldessari, or even to Lawrence Weiner. However this strikes me as crucially missing the point. For each of those figures, text was deployed in a concrete manner as a form of material signifier, but nothing could be further from Terada's standardised blocks of appropriated print and sly plays with meaning. This is not to say that his art does not stand in close relation to Conceptual precedent, only that, as William Wood has pointed out, this relation is one of belatedness and is consistently articulated through his 'purloining, waylaying, and malingering in the history of conceptual art.'[8] The tenor of his work is much closer to the ironic distance imposed by Richard Prince's joke paintings of the late 1980s, and indeed at times Goldstein's life – the downbeat trailer, the drugs, the general sense that he was born to lose – reads like a mirror of the white, lowbrow culture to which Prince's works so often refer. But the reference to Prince here is little more than an analogy, although Terada did spend the summer of 1990 in New York when a student, at the moment those paintings received their initial reception. All of this is to say, schematically, that over and against Vancouver's general alignment with the legacy of 1970s conceptualism, Terada would instead engage with the recalcitrant heritage of Warhol as it was available to him at the moment of his first major works.

It is, needless to say, a paradoxical point of orientation, but Goldstein himself was an artist who came of age in a thoroughly post-Warholian moment. Much of the subtext of his memoir concerns precisely the complexities of

7. Christopher Brayshaw perceptively re-marked on this aspect of the *Personal Paintings*: 'We sense that the writer's message, like his year-long search, is futile. The ad is not so much a plea for reconnection, as it is a small monu-ment to loss. The text and monochrome spur contemplation of the missing time between them….' See Brayshaw, 'Spotlight: Mono Maniac,' *Canadian Art* 17, no. 2, Summer 2000, p. 38. On the 'task of mourning,' see Yve-Alain Bois, 'Painting, The Task of Mourning,' in *Endgame: Reference and Simulation in Recent Painting and Sculpture*, Institute of Contempo-rary Art, Boston and MIT Press, Cambridge, Mass., 1986, pp. 29-49 – an essay Terada acknowledges as having a decisive impact on him at this time, an influence that is evident in his 1995 essay 'Abstraction and Abandon-ment,' written for the artist David MacWilliam, available at http://www.davidmacwilliam.ca/index.php?/textsessays/ron-terada/.

8. William Wood, 'Offensive,' *Public* no. 28, Winter 2003, p. 96.

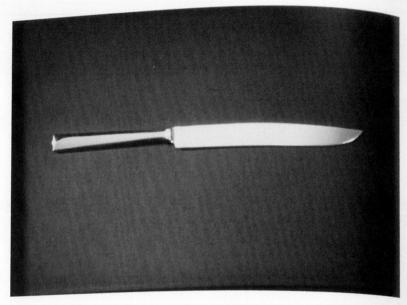

A Gla...
1972

6. Je...
Golds...
Galeri...
7. 'I d...
realiz...
perfor...
creati...
(see ...
p. 42)...
8. Do...
Sprin...
reprin...
Repre...
York/...
1984,...
9. Fra...
Sie d...
1973,...
10. *D...*
cat. K...
Cente...
p. 89...
11. se...
Galer...
Frieze...

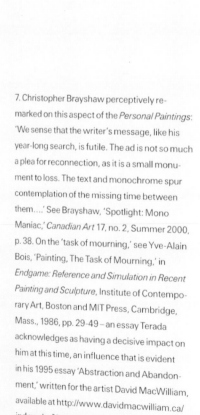

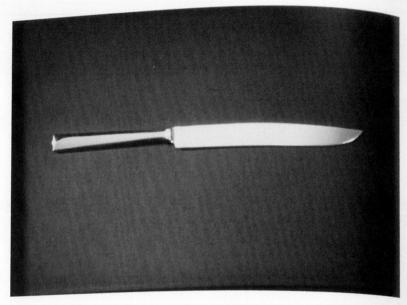

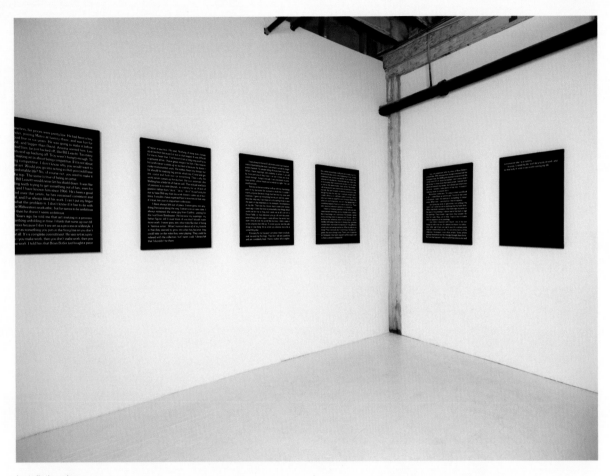

Installation view
Artist's studio, Vancouver, 2010

negotiating the place charisma had assumed in the determination of artistic value; by the end of the 1970s, the role of the artist had been assimilated into the model of the movie star (albeit on a significantly smaller scale), and the ability to successfully 'sell oneself' or allow oneself to be marketed had become a central aspect of the art market. Goldstein's repeated comparisons with his one-time colleagues at CalArts, most notably David Salle, in their alternation of resentment and superiority, are symptomatic of this new world. Little wonder that Terada should turn to this text now, at the conclusion of a decade-long binge that saw art, marketing, and fashion fused into an offshoot of the luxury goods trade and that witnessed the apotheosis of the artist-celebrity. Goldstein provides both a wry prehistory of this phenomenon, and an inside glimpse at its psychological toll.

Warhol not only presides over this content of the *Jack* paintings, their thematics of ambition and fame, but his legacy is apparent in their form as well. While Terada's new works are to some degree determined by Goldstein's own painterly decisions (the black and white colour schema, the use of semi-mechanical aids like tape or stencils, the refusal of 'over-finish'), they could also be understood as

Arranged by Louise Lawler, New York City, 1982

Installation with works from the inventory of Metro Pictures, New York

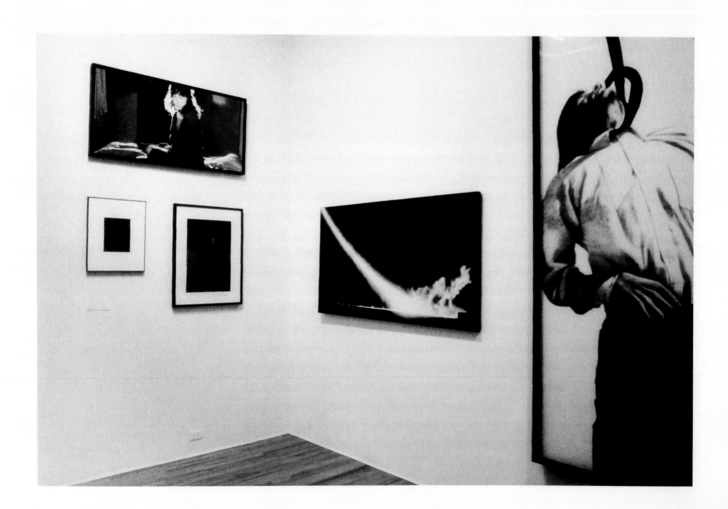

58

uninflected Warholian monochromes overlaid with text, rather than as restatements of conceptual abstention. Of course there is a willfully perverse aspect to such a reference: Warhol could be considered the constitutive exclusion around which the intellectualised Vancouver scene was articulated, and to have recourse to his work represents something like a challenge to its founding assumptions – although Terada is not alone among Vancouver-based artists in this gesture: Steven Shearer, who graduated from Emily Carr College of Art and Design a year after him, could similarly be aligned with a Warholian paradigm. But the contrariety of these works goes deeper: if Terada's earlier production had been the result of a painstaking pictorial labour, the quality of his new painting is notably straightforward, refusing that level of 'polish.' As has frequently been noted, Terada's monochromes of the mid-1990s were meticulously made, the hand-painted grounds the end result of dozens of layers of acrylic scrupulously cross-brushed to achieve smooth, highly finished surfaces that were then 'defiled' by the superimposition of the text layer, which seems to float on top.[9] Now, however, the purely mechanical aspect of painterly technique is brought to the fore; but this refusal of finish is accompanied, as we have seen, by a refusal of the intellectual labour typical of Vancouver's post-Conceptual milieu – a tendency recently parodied, for example, in Rodney Graham's *The Gifted Amateur, Nov 10th, 1962* (2007).[10]

Perhaps we could say, then, that the *Jack* paintings could be subtitled, to paraphrase Terada's famous highway sign, *Leaving City of Vancouver* or more accurately, that they continue the latter's engagement with the weaving together of oeuvre, market and place precisely by reading his hometown through the lens of Goldstein's New York. Should these paintings be read as self-portraits? He has admitted, after all, that 'Jack's "dropping and walking away" from a medium or method of working in favour of another seems to mirror my own trajectory,' but we should be wary of any simplistic identification. Instead, we may better see his new work as a gesture not unlike Allen Ruppersberg's writing of the text of Oscar Wilde's *The Picture of Dorian Gray* in longhand with a felt-tip pen across twenty large panels of white canvas; that 1974 work took up a contemporary conceptualist gesture – transforming a space for looking into a space for reading – and gave it an unexpectedly autobiographical spin, even as it engaged self-reflexively with the act

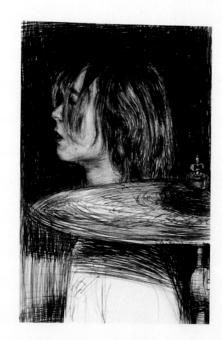

Drummer, 2005
Ballpoint on paper, 15.5 x 22 cm
Collection Herbert & Annette Kopp, Munich

9.
See, for example, the description provided by fellow artist Lucy Hogg, in her essay 'Mimics,' in *Type-Cast: Ron Terada, June Arnold, Steven Shearer*, Charles H. Scott Gallery, Vancouver, 1995, n.p.

10.
His engagement with that milieu is of course rather more complex than one of straightforward 'refusal,' and he has noted that 'my model for painting in some ways derives from Ian Wallace,' whose 1992 text 'Photography and the Monochrome: An Apologia, an Exegesis, an Interrogation,' provided some of the terms for Terada's text-based painting practice. See *Cameres Indiscretes*, ed. Jose Lebrero Stals, Centre d'Art Santa Monico and Generalitat de Catalunya, Barcelona, 1992, pp. 119-122.

of painting (*Dorian Gray* being a story of a painting and the passage of time).[11] Ruppersberg's gesture was one of re-enactment, and Terada's art has similarly been characterised as masquerade or mimicry; the slight distinction in terms is important. Certainly in the *Jack* paintings, he reproduces a text verbatim, but at bottom the accurate reproduction of his model is not what is at stake. This core of the imitative act, psychoanalytically speaking, lies in being 'inscribed in the picture', in being 'inserted in a function whose exercise grasps' the mimic himself.[12] Is Ron Terada Jack Goldstein? No, but Goldstein— whose work itself was about disappearing, behind actors, behind assistants— serves him as a form of camouflage, and perhaps of travesty.

In mimicry, it might be said, we do not so much imitate the image into which we want to fit, but rather 'those features of the image that seem to indicate that there is some hidden reality behind.'[13] Mimicry generates the illusion of another, hidden reality behind the image, in this case, the 'myth' of Jack Goldstein and, beyond this, Terada's own status as artistic subject. Seen in this light, the *Jack* paintings become only the latest link in a long series of ventriloquising performances, from the *Personal* and *Grey Paintings* of the 1990s to his more recent *Voight Kampff* video wall (2008), with its neo-Orientalist masquerade. As heterogeneous as these works are, the logic of camouflage unites them all, and the outlines of Terada's practice begin to become more clear: out of its surface diversity, we discern a practice struggling to produce a margin of autonomy for its author amid the overwhelming weight of the factitious present. The *Jack* paintings are the index of that personality crisis.

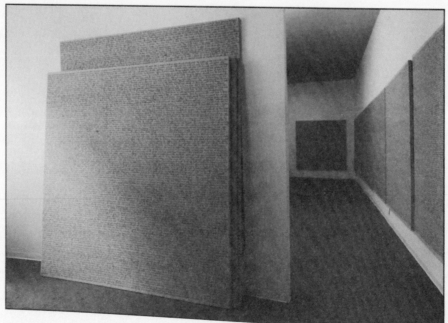

The Picture of Dorian Gray, 1974, 20 panels, each 183 x 183 cm, felt-tip pen on canvas, Judy and Stuart Spence, Los Angeles, installation view Claire Copley Gallery, Los Angeles, 1974

Tom McDonough

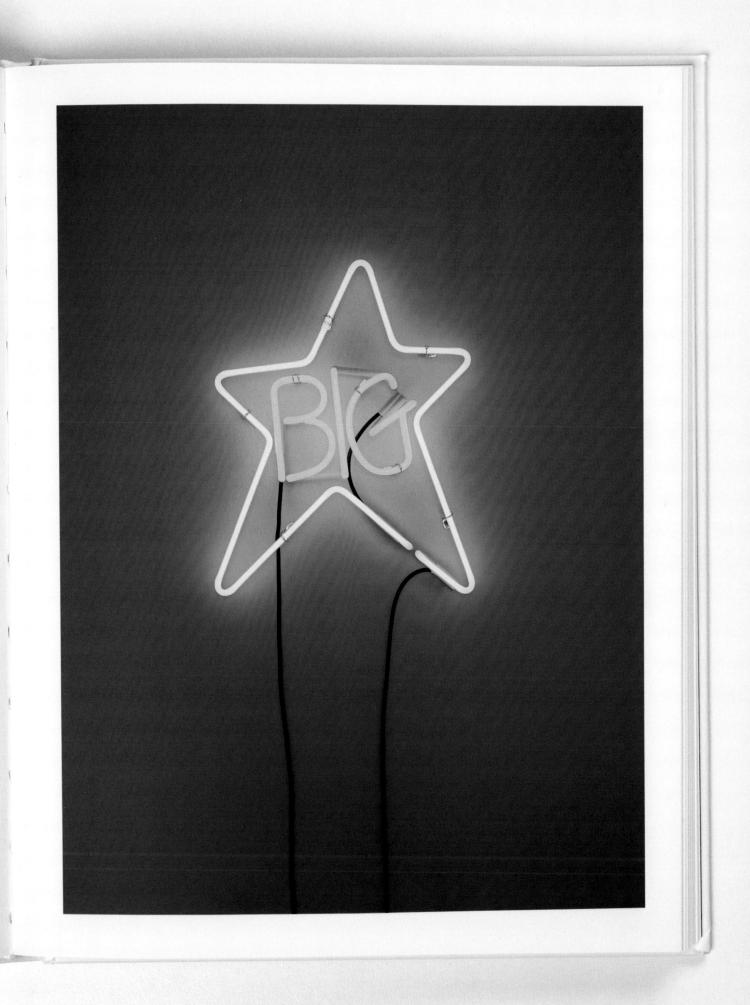

Notes

1. Chrissie Iles, 'Vanishing Act,' *Artforum* 41, no. 9, May 2003, p. 24. Goldstein had his first solo show in over a decade in Los Angeles in 2001, and was the subject of a 2002 retrospective at the Luckman Gallery, Cal State, Los Angeles.

2. See Richard Hertz, *Jack Goldstein and the CalArts Mafia*, Minneola Press, Ojai, Calif, 2003).

3. On the question of being 'in it for the money' in relation to Terada's recent work, see Reid Shier, 'Follow the Money,' in *Ron Terada*, Contemporary Art Gallery, Vancouver, 2003, pp. 7-16.

4. The gesture is not unique to Terada. In the 1980s British artist Simon Linke made what his colleague Julian Opie called 'very exact and beautiful oil painted copies' of *Artforum* advertisements; Opie's description of his motivation is telling: 'It was like he was painting his own ambition and it was so outrageous to be doing that, because of course we were all flicking through the magazines, looking at who was getting ahead and thinking how can we do that?' We should acknowledge, however, the different roles played by a journal like *Artforum* in a centre like London and Vancouver, which was still very much 'an outpost,' as Terada describes it, a fact which certainly lends distinct qualities to these two bodies of work. See John-Paul Pryor, 'Art Histories: Julian Opie,' accessible at http://dazeddigital.com/ArtsAndCulture/article/5594/1/Art_Histories_Julian_Opie_.

5. See the excellent discussion of these works in John Armstrong, 'Masquerade (Ron Terada),' in *Masquerade: Lucy Hogg, Tulsa Kinney, and Ron Terada*, Mercer Union, Toronto, 1997).

6. All quotes from Terada are from correspondence with the author, 18, 31 October and 3 November 2009.

7. Christopher Brayshaw perceptively remarked on this aspect of the *Personal Paintings*: 'We sense that the writer's message, like his year-long search, is futile. The ad is not so much a plea for reconnection, as it is a small monument to loss. The text and monochrome spur contemplation of the missing time between them....' See Brayshaw, 'Spotlight: Mono Maniac,' *Canadian Art* 17, no. 2, Summer 2000, p. 38. On the 'task of mourning,' see Yve-Alain Bois, 'Painting, The Task of Mourning,' in *Endgame: Reference and Simulation in Recent Painting and Sculpture*, Institute of Contemporary Art, Boston and MIT Press, Cambridge, Mass., 1986, pp. 29-49 – an essay Terada acknowledges as having a decisive impact on him at this time, an influence that is evident in his 1995 essay 'Abstraction and Abandonment,' written for the artist David MacWilliam, available at http://www.davidmacwilliam.ca/index.php?/textsessays/ron-terada/.

8. William Wood, 'Offensive,' *Public* no. 28, Winter 2003, p. 96.

9. See, for example, the description provided by fellow artist Lucy Hogg, in her essay 'Mimics,' in *Type-Cast: Ron Terada, June Arnold, Steven Shearer*, Charles H. Scott Gallery, Vancouver, 1995, n.p.

10 His engagement with that milieu is of course rather more complex than one of straightforward 'refusal,' and he has noted that 'my model for painting in some ways derives from Ian Wallace,' whose 1992 text 'Photography and the Monochrome: An Apologia, an Exegesis, an Interrogation,' provided some of the terms for Terada's text-based painting practice. See *Cameres Indiscretes*, ed. Jose Lebrero Stals, Centre d'Art Santa Monico and Generalitat de Catalunya, Barcelona, 1992, pp. 119-122.

11. Terada has compared the Jack paintings to Ruppersberg's work in an e-mail to the author, 18 October 2009. Tim Griffin described *The Picture of Dorian Gray* (1974) as 'a kind of anxious elegy to the task of painting' that 'reflected its day's deep skepticism about the medium, but only with a sublime irony, re-presenting Wilde's testament to art's power to transform the world.' See his 'Tim Griffin on Allen Ruppersberg,' *Artforum* 45, no. 7, March 2007, p. 286.

12. Jacques Lacan, *The Four Fundamental Concepts of Psycho-analysis*, ed. Jacques-Alain Miller, trans. Alan Sheridan, W.W. Norton, New York and London, 1998, pp. 80, 100.

13. See Slavoj Zizek, *How To Read Lacan*, accessible at www.lacan.com/zizbouyeri.html.

In the end, I want my legacy; that's the most important thing for me. As it is, I went much farther, I did much better than I expected. I keep remembering Matt Mullican, who had some real wisdom; he was always telling me that the thing we had to do was to wait for the previous generation to die out.

Matt said that it's like the base of a triangle: It gets narrower as it reaches the top. As those who are at the top die out (if not literally, then at least their reputations), there will be room for people like us to push in, and that's what happened. With the opening of Metro Pictures in 1980, a new decade began; all of a sudden there was an upsurge of galleries, and those of us who had come from CalArts, with our ideas about pictures and appropriation, got a lot of attention.

After I returned to Southern California, I lived for ten years as a failure. What had I done wrong? I had made so much work but didn't know what would happen to it. Now it is being kept alive again. Some people are keeping alive what I did, but for so long I worried it had been lost and forgotten.

Myths about my drug use have been following me for over thirty years; someone who was involved peripherally with the artworld came in to see my April 2001 show at Brian Butler's, someone I hadn't seen for years. Even she knew about my alleged drug use. If you can't

say anything about the work, go after the artist! It's important to know that I am entirely responsible for myself. I never borrowed drugs from anybody; I never begged; I never hustled anybody. I was a one-man operation.

I have nothing to feel embarrassed about, nothing to feel uptight about. I never had stable teaching jobs, which don't make you a better artist. In fact, they make you a worse artist. It is all too easy to rely on that monthly check and to lose your ambition to succeed as an artist.

In New York teaching was a no-no; if you were teaching, it meant that you were not making it. I still remember when David and I pulled into the parking lot at Hartford and he told me that he was quitting his teaching position so that he could work full time as an artist. He made a point of saying "working full time as an artist." That meant to me, if you're teaching, you're not working full time as an artist. That's why there is that snobbery. Now it is difficult for me to get back into teaching because the same people are at the colleges and universities and art schools who were there when I didn't need to teach. They resent me for it. Then I didn't need to teach and they resent me for it.

I don't have enough fingers and toes to count the number of times people tell me that my work has been a strong influence on them; instead of having art careers they had teaching careers. A teacher might think he or she has an art career, but usually it is stuck somewhere in

Ron Terada, *Jack*, 2010, acrylic on canvas, 30 x 24 in.

the middle of the pack. As I have always said, schools are about mediocrity; art is about excellence.

In 1993–94, Richard Hertz at Art Center hired me to teach a class on recent art theory and to have studio visits with the grad students. You can see how desperate I was! In New York I received a lot of good offers for teaching jobs, but I always had to turn them down because I never had the time. For six years I did teach part time at the School of Visual Arts, but finally they had to let me go. One of the things about Jeanne Siegel and Paul Waldman is that despite the fact that they brought you in because of your reputation, no matter where you were exhibiting, you still had to show up for your classes. The truth is that half the time I had to ask friends and students to take over because I had to go somewhere. It was part time, and I had to come in one day a week, but it paid decently. Through teaching at SVA I got to know Joyce Roetter, who had gone to grad school at Art Center. She suggested I go to L.A. to teach; at first I took a rain check, but a few years later I moved.

In 1993 I almost got the University of California, Riverside teaching job. I had a meeting with the Provost, that's how close I was to getting it. He said that based on my resume, I would be underpaid if I took the position. There was no comparison between the quality of my resume and the resumes of those on the faculty. At the last minute there was a big fight about my appointment. Apparently

a faculty member who had been there for a long time said that he didn't want some hot shot New York artist on the faculty. They ended up choosing Jill Giegerich. It was during this process that I met Uta Barth; she was the one who informed me that I was not going to be hired. She said that because it's a very small faculty, they didn't want to get into a big departmental fight. It's a small department, there's little pressure, there are no graduate students, and you get top dollar for being there. Uta complained that she has to fight the traffic driving out from the west side of L.A. I had to laugh when she told me that.

A lot of people say that Jack Goldstein is a real legend—reclusive, brilliant. A loner, shy and uncomfortable. I just wish those fans of mine would come forward. I may be a legend, but for eight years I was living in a trailer in East L.A. without electricity or running water. A broken-down trailer that leaked. No refrigerator. No eating facility. Barely a toilet. Eight years! I had no choice; I had to take shit jobs. I bought a little piece of land where cholos lived. There were gunshots going off all around me. I got along with those cholos; they fed my dogs when I was gone. On Friday nights they would steal automobiles and strip them in front of my gate. Finally, I had to tell them to strip the cars several feet from my gate so I could get out, which they did. In spite of their criminal behavior, I generally liked them as people better than those I knew in the artworld. The only

time I got a little frightened was when they turned eighteen years old, when they became aware of their Mexican heritage and realized that I was white. I would have conversations with them and then go inside and write poetry. I grew up understanding extremes and oppositions.

I was no longer a New York artist. No one knew of my past and no one asked. I picked up stray dogs, like myself, and ended up with five. That was my family life and still is. What kept me going was writing my autobiography as a series of aphorisms. I read Heidegger and Kafka backwards and underlined the parts that excited me. I spent from eight to twelve hours a day reading books backwards in order to break the narratives and mimic the lack of continuity that existed in my own life.

My family worried I was going to hurt myself and had me locked up for three days in a psycho ward. The police showed up and couldn't believe I was living with no electricity or running water. When they turned on my kitchen taps and no water came out, that did it for them. They told me to turn around and handcuffed me. I can still remember sitting in the backseat complaining how tight the handcuffs were and that I wasn't crazy, just down on my luck! It was as if I were a criminal for being myself. I kept telling them that I never learned how to live like most people; I am a self-exiled pariah. No one wants me around, so I retreat more and more. The locals in the area fed my dogs while

I was gone. These were the same local hoods who gang-banged and fired their guns in the air at night. Whenever they killed someone, they would come over to my fence and yell my name to brag about it.

Since my trailer was on a cul-de-sac, there were drugs all around me. One person who lived ten yards from my gate sold heroin out of his broken-down van. That was convenient for me, but increasingly I was worried about my safety and that I would be robbed. For two years I pleaded with him to sell drugs further away from my trailer; finally I covertly called the police. After two years he returned from prison and asked if he could stay in my place for a week until he returned to a half-way house. On the Thursday prior to leaving, he overdosed in my trailer. I went to touch him in the morning and he was frozen.

I used to go at 5:00 in the morning to places called the "American Labor Force." I would sit there for three hours waiting for someone to hire me. First come, first served. You get there at 5:00 in the morning, and if a job comes in, they send you out on it. Anything from wrapping boxes to construction. You get $50 a day and bring home about $38 a day. I worked for Marie Callander; I used to bring a receptacle along that had food in it. "Marie Callander is here." They would get a third of whatever I made. I delivered newspapers for two years and threw *USA Today* into Johnny Carson's Malibu driveway. I put signs on car windshields

Jack, 2010
Ron Terada

for Bally's, a workout place; after paying for gas, I might bring home $30 a day. I washed dogs; I tried to train dogs. For almost two years, I did these kinds of jobs.

For a while, I lived in Venice with the friend of one of my assistants. We decided to cultivate marijuana, which I never used, and I invested a lot of money in fans, a generator, growing lights, the seeds, and a watering system. I was desperate and it seemed like it would be profitable, a good cash crop, and an easy way to make money. Suddenly I became a farmer. Day and night, we watched over the plants and after a few months had a great crop, which we processed. My friend took the marijuana to New York, where he was going to sell it and then return to divide the proceeds. He left and I never heard from him again. I was worried the cops would raid the house because the smell alone could make you high. One day I packed up and moved, leaving behind all of the growing paraphernalia.

Then I owned an old second hand ice cream truck that I bought for a few hundred dollars. Every day after buying ice cream, I went to different clinics all over L.A. to get methadone; if I tested positive for drugs at a clinic, they wouldn't give me any, so I had to go to another one. I stood in line in my white pants and white shirt, my white hat in my pocket. After a while I learned to take along a bottle of someone else's urine, in case they wanted a urine sample. One day, it took so long at the clinic that my ice

cream melted; I re-froze it as best I could and sold it to the Chicano kids. I sold ice cream in East L.A. so that during the day I could buy the drugs I needed.

My parents would help me out a little bit to get by, but they couldn't understand my situation. If I didn't go out on a job, I spent most of the morning feeding my dogs, then going to clinics for methadone. If I couldn't get any, I spent most of the rest of the day looking for drugs. The ritual of feeding my dogs, writing, and finding drugs organized my life. I was at the bottom of the barrel. My resume meant nothing. What else could I do? I had no money to make art, and anyway the auction prices were horrible. That is why I disappeared. I lost most of my teeth because of all of the heroin I was using and had to have temporary ones put in at the UCLA Dental Clinic, where they have a free clinic for indigents. I was embarrassed by my situation. Am I going to hang out with Jim Welling and Morgan Fisher and then say, I've got to do menial labor while you go off to UCLA to teach? I just disappeared.

I took awful jobs and came home in the pitch black, so I had to light candles in my trailer. Turn on my battery-powered radio. I went back to what I used to do when I first got out of school, only worse. I can't tell you how many times I wanted to swing by a rope. There was no one around; anyway, who would want someone in my situation? I have a very dim view of people. I don't trust people;

deep down, I don't trust them. It wasn't like me to write to Art Center for a job, but I was at the end of my rope.

In 1993 I overdosed on pills. That night I stayed at my sister's. I told her, I'll see you in the morning; I'm going to bed. I wasn't hysterical at all. I went to the bedroom and took ninety-seven Tylenols; I counted them as I took them. They looked like footballs, green footballs. I said to myself, I'm going to check out. I've had my time here; I've created a body of work. As I was taking them, I was talking with Rebecca on the phone; Rebecca had the feeling that I was up to something. She called my sister, who found me. I went out cold in a matter of one minute. After that I was in the hospital for a week. They gave me a fifty-fifty chance to make it. I don't remember anything until a week later. I was out for seven days, out cold; it was totally black. If anyone tells you that there is a light at the end of the tunnel, or that you see something, they are wrong; there ain't nothing. It is black. When I woke up, the first thing I heard was nurses saying, God, I could never do that to myself. I should have gone down to my car before I took the pills and then it would have been over.

If I had some savings, if I knew I was guaranteed a check each week, then I might paint again. It is such a gamble. Who knows if people would be lining up to buy a painting? The work didn't sell under optimum conditions; it makes me wonder. I don't want to run scared anymore.

What Brian Butler has done for me recently is more than all of my previous dealers combined. I had dealers all over the world and they never worked for me like that. Recently, Daniel Buchholz and Christopher Müller in Cologne have also worked very hard for me. My art was ahead of its time; the digital, computer-generated language that Koons used in his 2001 Gagosian show was a language I had used in my paintings fifteen years earlier. Hiring other people to apply the paint was a no-no for me but it isn't a no-no for him. Koons doesn't physically make those paintings, and that is okay, but I was severely criticized for doing that.

In 2001 I had a show in Germany; Jim Welling had the next show. People grow up—they have kids, they teach, but I still remember the CalArts days. I'd go over and say, Jim let's do a record. What do you think? But he wasn't interested. I ran into Matt and it was the same thing. I said, I heard your dad died; what was that like? I knew he was really close to his family. He said, I'm a dad now; I have twins. That was it; he's a dad. That summed it up—he has replaced his father by becoming a father. I understood exactly what he meant. In a way, he has gone beyond that earlier relationship so he can be wrapped up in being a dad. He's not little Matt anymore; all of a sudden Matt has grown up.

Troy Brauntuch is teaching at the University of Texas, Austin. Whenever I was at Sotheby's or Christie's, I would look under "B" to see if one of his paintings had come up

73

SO WERE PEOPLE THIS DUMB BEFORE TELEVISION?
1998
sign writing on wall
variable
A line from the book DISCUSSION ISLAND: BIG
CONFERENCE CENTRE. A post-textual device in relation to
the project in general.
LIAM GILLICK, JOHN MILLER, JOE SCANLAN, RAK Vienna,
February 1998 / PLACES TO STAY 4 P(RINTED) M(ATTER),
Büro Friedrich, Berlin, 1998

Schriftzug auf einer Wand
variabel
Eine Zeile aus dem Buch DISCUSSION ISLAND: BIG
CONFERENCE CENTRE. Ein nach dem Text entstandener
Kunstgriff mit Bezug
zum Projekt im allgemeinen.
LIAM GILLICK, JOHN MILLER, JOE SCANLAN, RAK Wien,
February 1998 / PLACES TO STAY 4 P(RINTED) M(ATTER),
Büro Friedrich, Berlin, 1998

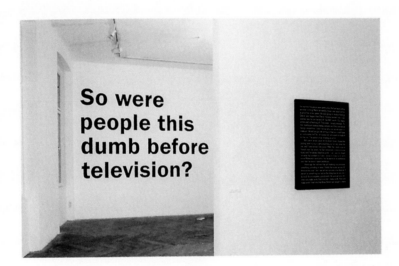

of mine at auction. He said, Nothing of mine ever comes up at auction because I'm not in that league. It was difficult for me to hear that. I've known him a long time and he is a genuine artist; I have great respect for him. One reason his work never comes up at auction is because he doesn't make monumental work. He makes these tiny things, but he should be making big pieces which say, Come and get me, come and fuck me—or something. That's why his work never comes up for auction. He's too reserved. Jim Welling has a little bit of that as well. This attitude and lack of passion is so anti-Jewish, so contrary for us. A lack of passion rather than "do it," "do it," "do it." It was funny for me to hear Bill say that his work doesn't come up at auctions. I wouldn't have expected him to kow-tow in that way; it's true, he's not in important collections.

I have always felt out of place. I never grew into anything I became along the way. I never took on new roles. I always remained the same guy from CalArts, waiting for the nod from Baldessari. He became my superego, my father figure. All I could think of was that I should make more work. I never grew into other roles like that of being a "famous artist." What I noticed about all of my friends is that they seemed to grow into what they became; they could take on the roles they were playing. They could be relaxed with the collectors, but I never could; I always felt that I shouldn't be there.

I was always in turmoil. I did more work than I needed, overcompensating because I was afraid I would be caught empty handed. I'm always biting off more than I can chew. When I have meetings with students or artists, I can tell by their persona if they have it or not—if they are motivated enough, hungry enough. I am interested in ambitious artists, whose heads are screwed on right. You can smell success.

Success in the artworld as well as with my friendships and in my personal life seemed to elude me. I couldn't marry anyone because drugs had become my lover and mistress. I gave up everything for my art and my career. And the only way I can make art is by taking drugs to ease the pain of the emptiness in my stomach, the emptiness of my life. That was the choice that I made over twenty years ago. I have the kind of personality that things either work out for me or they don't work out at all. I am not a David Salle, so that wherever you go, all over the world, everything falls into place. I went all over the world, but I didn't live all over the world like he does. I didn't want to screw anyone else's life up. To screw up your own life with drugs is one thing, but to screw up someone else's life is something else.

It's scary for me because I am alone; there is nobody, only me and my five dogs. They don't ask any questions and are completely loyal. I have a mother who is eighty

five; a father whose brain is half gone and is ready to go. It's the end of the line and it's very frightening for me. I finally understand that people have families so you always have someone to look after you. About five years ago, when I was in the hospital after a motorcycle accident, no one came to visit me. My sister wouldn't even call me. She wouldn't call me because it was a motorcycle accident and so it was my fault. She said I shouldn't be driving a motorcycle, even though that was the only way I could get around when I couldn't afford a car. I still have a plate in one leg; I had to take a taxi home by myself. It's scary because I realize that when you are living alone, you can't live dangerously; if something happens, there is no one to care for you. There won't even be someone to push me in a wheelchair.

I listen to Christian preachers on the radio and television because what they say is so foreign to me; I always like to hear things I can't understand. For example, I spend hours watching shows in Japanese and Chinese. I like to be thrown into situations where I'm the outsider; I am so familiar with being in that kind of situation that I gravitate towards them, even when I'm watching TV. My girlfriends would come over and get mad at me: What the hell are you doing? That's precisely why I watch those Christian programs; they are so foreign to me. There's a lot of paganism in Christianity; they had to appeal to all the pagans, and so there is almost no Judaism left.

I was very depressed after my show at Brian Butler's in April-May, 2001 because even though everyone told me how great I was, Jim Welling was buying a house around the corner from UCLA, where he teaches. I don't know what I did wrong; I've done more than most people. I should have saved and invested my money, but I always put it back into the work. I wouldn't trade places in that way—I wouldn't trade my career for anyone else's.

My fortune cookie says, "It is easy to think but difficult to act." I called Brian up and he said, You're on the cover of *Artforum*. I said, You have got to be kidding. It's bitter-sweet. When I don't care anymore, then it happens.

I am typing my book of aphorisms, not writing it by hand. I can't stand to look at anything that my hand does. When I had studio assistants, I had them sign my name on the back of the paintings. I almost had to fire them to sign the paintings. They wouldn't sign them; they wouldn't do that. So I said, Okay, you're fired. I had so much trouble with the signature on my paintings.

I was naïve compared with David; one of the last things he said to me was, It's absurd out there; it is ridiculous. I didn't get it then, but I get it now. At a certain point it doesn't matter what you do. You are at the mercy of the collectors, the dealers, even other artists. Some artists squeeze themselves into the triangle through sheer force. But how that happens—why one artist becomes a star and

1.15
Ron Terada
Jack, 2010
Acrylic on canvas
Courtesy the artist and Catriona Jeffries Gallery

77

not someone *else*—is a mystery.

 In a way, I ruined my life, but I did a body of work, and for that body of work it was worth ruining my life.

Biography

Ron Terada was born in 1969 in Vancouver, British Columbia, Canada. After a short spell working as an apprentice bow maker, he began his career as an artist. He studied at the Emily Carr College of Art & Design in Vancouver between 1987 and 1991 and still lives and works in Vancouver.

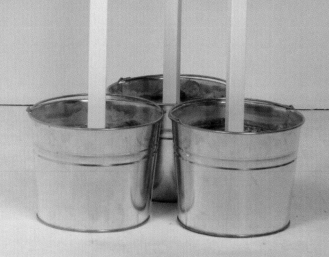

Exhibition History and Bibliography

Note: In Japanese-speaking contexts, the artist's name is spelled ロン テラダ.

Solo Exhibitions

2011
Who I Think I Am, Justina M. Barnicke Gallery, Toronto

2010
Project Space: Ron Terada, Hayward Gallery, London

Etablissement d'en face, Etablissement d'en face, Brussels

Who I Think I Am, Ikon Gallery, Birmingham and Walter Phillips Gallery, Banff.

2008
Voight-Kampff, Catriona Jeffries Gallery, Vancouver

2006
Stay Away from Lonely Places, Ikon Gallery Off-site, Birmingham

2005
You Have Left the American Sector, Art Gallery of Windsor

Stay Away from Lonely Places, Catriona Jeffries Gallery, Vancouver

2003
Catalogue, Contemporary Art Gallery, Vancouver

2002
Entering City of Vancouver, Catriona Jeffries Gallery, Vancouver

Big Toast, iprojects.org, Charles H Scott Gallery, Vancouver

2000
Soundtrack for an Exhibition, Or Gallery, Vancouver

Soundtrack for an Exhibition, Western Front, Vancouver

1999
Jeopardy Paintings, Catriona Jeffries Gallery, Vancouver

What's the Question, Real, New York

1998
Present Tense, Art Gallery of Ontario, Toronto

1997
Grey Paintings, The New Gallery, Calgary

Grey Paintings, Or Gallery, Vancouver

SELECTED
GROUP
EXHIBITIONS /

GRUPPEN-
AUSSTELLUNGEN
(AUSWAHL)

2010

»Power Alone,« curated by Juan Gaitan,
Witte de With Center for Contemporary
Art, Rotterdam
»Gallery, Galerie, Galleria,« curated by
Adam Carr, Norma Mangione Gallery,
Turin

2009

»The Store,« curated by Adam Carr,
Artissima, Turin
»Morality,« curated by Nicholaus
Schufhausen, Witte de With Center for
Contemporary Art, Rotterdam
»Arena: The Art of Hockey,« Museum of
Contemporary Canadian Art, Toronto
»Loaded,« Catriona Jeffries Gallery,
Vancouver
»Signals in the Dark: Art in the Shadow of
War,« curated by Séamus Kealy, Model
Arts & Niland Gallery, Sligo, Ireland
»In Print,« curated by Adam Carr, e-flux
project space, New York

2008

»Tractatus Logico-Catalogicus,« curated
by Klaus Scherübel, VOX Centre de
l'image contemporaine, Montréal
»SCAPE Christchurch Biennial of Art in
Public Space, Wandering Lines: Towards
a New Culture of Space,« curated by
Fulya Erdemci & Danae Mossman,
Christchurch, New Zealand
»The Store,« curated by Adam Carr,
Tulips & Roses, Vilnius, Lithuania
»Arena: The Art of Hockey,« Art Gallery of
Nova Scotia, Halifax
»Signals in the Dark: Art in the Shadow
of War,« curated by Séamus Kealy,
Blackwood Gallery, University of Toronto
at Mississauga (travels to Leonard & Bina
Ellen Art Gallery, Concordia University,
Montréal)

COLLECTIVE EXHIBITIONS

2007

Without, Yvon Lambert, Paris

Plan Large, Le Mois de la Photo: Replaying Narrative, Fonderie Darling, Montréal

Sobey Art Award, Art Gallery of Nova Scotia, Halifax

Words Fail Me, Museum of Contemporary Art, Detroit

For Sale, Cristina Guerra Contemporary Art, Lisbon

The Idea of North, Isabella Bortolozzi Galerie, Berlin

The Monochromatic Field, Morris & Helen Belkin Art Gallery, Vancouver

2006

The Show Will Be Open When The Show Will Be Closed, Kadist Art Foundation, Paris

Recent Acquisitions, Musée d'art contemporain de Montréal

Paint, Vancouver Art Gallery

Concrete Language, Contemporary Art Gallery, Vancouver

6th Shanghai Biennale: Hyperdesign, Shanghai Art Museum, Shanghai

The Show Will Be Open When The Show Will Be Closed, Store Gallery, London

Territory, Artspeak Gallery and Presentation House Gallery, Vancouver

274 East 1st, Catriona Jeffries Gallery, Vancouver

2005

Intertidal: Vancouver Art and Artists, Museum van Hedendaagse Kunst Antwerpen, Belgium

Re-Play, Museo Carillo Gil, Mexico City

Monkey Work Coconut: Ron Terada, Xu Zhen, Mercer Union, Toronto

General Ideas: Rethinking Conceptual Art 1990-2005, CCA Wattis Institute for Contemporary Arts, San Francisco

Post No Bills, White Columns, New York

Painting After Poverty, Catriona Jeffries Gallery, Vancouver

Wayleave, Ex Magazzini Generali di Roma - Istituto Superiore Antincendi, Rome

2004

2048km, Or Gallery, Vancouver

Re-Play, Ottawa Art Gallery, Ottawa

Prototype, Carleton University Art Gallery, Ottawa

Sign Language, Museum of Contemporary Art, Los Angeles

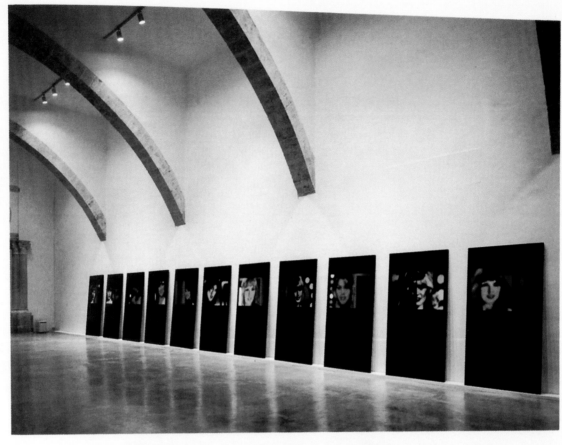

2003
Seattle Art Museum, Seattle (travels to Museum of
Contemporary Art, San Diego; Vancouver Art Gallery;
CCAC Wattis Institute for Contemporary Arts, San
Francisco)
'Baja to Vancouver'*

National Gallery, Prague
'Prague Biennial: Peripheries Become the Centre'*

Edmonton Art Gallery, Edmonton (travels to Blackwood
Gallery, University of Toronto, Mississauga; MacKenzie
Art Gallery, Regina)
'Soundtracks'

Catriona Jeffries Gallery, Vancouver
'I Sell Security'

Bard College, Annandale-on-Hudson, New York
'Subscribe: Recent Art in Print'

2002
Agnes Etherington Art Centre, Kingston
'Crack'

Catriona Jeffries Gallery, Vancouver
'Signage'

2001
Plug-In, Winnipeg
'Universal Pictures 3.1'

Contemporary Art Gallery, Vancouver
'Promises'

Blackwood Gallery, University of Toronto at Mississauga
'Universal Pictures 3'

Vancouver Art Gallery, Vancouver
'These Days'*

Museum of Contemporary Art, Sydney, Australia
'Art>Music: Rock, Pop, Techno'

Atelier Gallery, Vancouver
'Talk the Talk'

Dunlop Art Gallery, Regina
'Supersonic Transport'*

2000
Illingworth Kerr Gallery, Calgary
'Message by Eviction: New Art from Vancouver'

Trylowsky Gallery, Vancouver
'New Work: Jerry Allen, Ron Terada'

1999
Vancouver Art Gallery, Vancouver
'Recollect'

Monte Clark Gallery, Vancouver
'Universal Pictures 2'

Norwich Gallery, Norwich, UK
'East International'*

Melbourne, Australia
'Melbourne International Biennial—Universal Pictures'*

Monte Clark Gallery, Vancouver
'The High Life'

1998
Morris and Helen Belkin Art Gallery, Vancouver
'6: New Vancouver Modern'*

1997
Mercer Union, Toronto
'Masquerade'

1996
London Regional Museums, London, Ontario
'The Young Contemporaries'

Entertainers, installation at IVAM Centre del Carme, Valencia, Spain, 1989

1995

Dark Memories
Marc Foxx Gallery, Santa Monica

Invitational
Cold City Gallery, Toronto

Type-Cast
Charles H Scott Gallery, Vancouver

1993

Artropolis 93
Woodward's Building, Vancouver

Residence on Earth
Artemisia Gallery, Vancouver

1992

Know No Boundaries: The Billboard Art Series Public Art Exhibition, Active Artifacts Cultural Association & B.C. Transit/Skytrain, Vancouver

Selected Bibliography

2009

Carr, Adam, 'Trading Places: The Story of Defile,' *Ciel Variable, Medium: Magazines*, No. 83

Whyte, Murray, 'Stunning Sports Art Tilts to the Profane,' *The Star*, Toronto, April 18

2008

Bywater, Jon, 'Ron Terada,' exhibition catalogue, *SCAPE Christchurch Biennial of Art in Public Space, Wandering Lines: Towards a New Culture of Space*, Christchurch, New Zealand

Carson, Andrea, 'Bridging the Gap between War's Myth and Reality,' *Globe & Mail*, February 27

Hoffmann, Jens, 'For Sale,' exhibition catalogue, Cristina Guerra Contemporary Art, Lisbon

Mooney, Christopher, 'Ron Terada,' exhibition review, *Art Review*, Issue 24

Scherübel, Klaus, 'Tractatus Logico-Catalogicus,' exhibition brochure, Vox Centre de l'image Contemporaine, Montréal

Weir, Andy, 'Without,' exhibition review, Contemporary, No. 98

2007

Fraser, Marie, 'Replaying Narrative,' exhibition catalogue, *Le Mois de la Photo à Montréal: Replaying Narrative*, Montréal

Mende, Doreen, 'The Idea of North: Allison Hrabluik, Zin Taylor, Ron Terada,' exhibition review, *C Magazine*, No.94

Pakasaar, Helga, 'Ron Terada,' exhibition catalogue, Sobey Art Award 2007, Art Gallery of Nova Scotia, Halifax

Sholis, Brian, 'Talking about communication – with words by MOCAD guest curator Matthew Higgs,' *Metro Times*, Detroit, October 3

von Taube, Annika, 'Shortcuts: Ron Terada,' *Sleek Magazine: Solid/Liquid*, Berlin, No. 14, Spring

2006

Burnham, Clint, 'Artworks challenge and intrigue,' *The Vancouver Sun*, June 3

Dault, Julia, 'A room of one's own,' *The National Post*, June 15

Lauson, Cliff, 'Ron Terada,' *Contemporary, 21: Special Issue on Conceptual Art*, No. 85, September

McFadden, Sarah, 'Intertidal: Vancouver Art and Artists,' exhibition review, *Art Papers*, p 52, May/June

Rodney, Lee, 'Have you left the American Sector? Ron Terada's Adventure in the City of Roses,' *Fuse Magazine*, Vol. 29, No. 2

Watkins, Jonathan, 'Art and Design and Everything Else,' exhibition catalogue, *6th Shanghai Biennale: Hyperdesign*, Shanghai Art Museum

2005

Baker, Kenneth, 'Artworks emerge from the rubble of deconstructed memories,' *San Francisco Chronicle*, Oct. 1

Brayshaw, Christopher, 'Wit on the streets,' *The Globe & Mail*, May 27

Carlson, Tim, 'Free Manure, Bagged! And other signs of the times,' *The Globe & Mail*, May 20

Chen, Dalson, 'City orders art removed,' *The Windsor Star*, September 29

Danese, Roseann, 'Council debates artwork's merit,' *The Windsor Star*, September 20

Darling, Michael, 'Sign Language' exhibition brochure, Museum of Contemporary Art, Los Angeles, Summer

Continued selected articles and reviews:

2005
De Vito, Natalie, **Monkey Work Coconut**, exhibition brochure, Mercer Union, Toronto

Dick, Terence, **Ron Terada/Xu Zhen: Monkey Work Coconut** exhibition review, Camera Austria, No. 92

Elgstrand, Gregory, **Ron Terada** exhibition review, Canadian Art, Vol. 21, No. 2

Gleeson, David, **Baja to Vancouver** Canadian Art, Vol. 21 No. 2

Heather, Rosemary, **Censorship Bulletin** C Magazine, No. 88

Higgs, Matthew, **100 Future Greats: Ron Terada** ArtReview, Vol. IX, December

Higgs, Matthew, **General Ideas** in General Ideas: Rethinking Conceptual Art 1987 - 2005, exhibition brochure, CCA Wattis Institute for Contemporary Arts, San Francisco

Mahovsky, Trevor, **2048km** exhibition review, Artforum, Vol. XLIII No. 5

O'Brian, Amy, **Vancouver artist stirs up Ontario border city** The Vancouver Sun, October 1

Roelstraete, Dieter, **1,986,965 (2001 Census): An Intertidal Travelogue** exhibition catalogue, Intertidal: Vancouver Art and Artists, Museum van Hedendaagse Kunst Antwerpen

Scott, Michael, **Separating West Coast dream from reality** The Vancouver Sun, June 5

Turner, Michael, **Not so quiet on the Western front** The Globe & Mail, July 14

Wood, William, **Offensive** Public: Satan Oscillate My Metallic Sonatas, No. 28

2003
Augaitis, Daina, **Ron Terada** in Baja to Vancouver: The West Coast and Contemporary Art, exhibition catalogue, MCA, San Diego; Seattle Art Museum; Vancouver Art Gallery; Wattis Institute, San Francisco

Darling, Michael, **Can't Get No Satisfaction** in Ron Terada, exhibition catalogue, Contemporary Art Gallery, Vancouver

Dykk, Lloyd, **Pride of place in business-of-art-show show** The Vancouver Sun, December 6

Gandesha, Samir, **I Sell Security** exhibition review, Vancouver, Art Papers, p 61, Vol. 27 No. 6

Helfand, Glen, **Baja to Vancouver** exhibition review, Artforum, December

Laurence, Robin, **A Catalogue of Illusions** The Georgia Straight, Vancouver, November 13-20

Milroy, Sarah, **An Artful Anger, Driven to Extremes** The Globe & Mail, October 18

Ounpuu, John, **Ron Terada** in Prague Biennale, exhibition catalogue, National Gallery, Prague

Rugoff, Ralph, **Baja to Vancouver: The West Coast and Contemporary Art** in Baja to Vancouver: The West Coast and Contemporary Art, exhibition catalogue, MCA, San Diego; Seattle Art Museum; Vancouver Art Gallery; Wattis Institute, San Francisco

Turner, Michael, **View from Vancouver: Wall and Void** Modern Painters, Vol. 16, No. 2

Wood, Kelly, **Room to Maneuvre** in Ron Terada, exhibition catalogue, Contemporary Art Gallery, Vancouver

2002
Kealy, Séamus, **Ron Terada** exhibition review, Canadian Art, Vol. 19 No. 4

O'Brian, Melanie, **Promises: Espousal and Constraint** exhibition review, MIX Magazine, Vol. 27 No. 4

2001
Cramer, Sue, **Turn Up the Volume: Art into Music** in Art>Music: Rock, Pop, Techno, exhibition catalogue, Museum of Contemporary Art, Sydney, Australia

Derksen, Jeff, **Thing Culture: Ron Terada** C, Issue No.72

Dick, Terence, **Pop Art: Tunesmithing in the Work of Ron Terada and Rodney Graham** MIX, Vol. 27 No. 1

Fischer, Barbara, **Smoke and Mirrors** in Universal Pictures 3, exhibition poster/brochure, Blackwood Gallery, University of Toronto at Mississauga

Hayes, Kenneth, **Universal Pictures 3 at the Blackwood Gallery** MIX, Vol. 27 No. 3

Koh, Germaine, **Give Aways: A Partial Account** MIX, Vol. 27 No. 2

Roy, Marina, **These Days** exhibition review, Last Call, Vol. 1 No. 2

Wyman, Jessica, **Universal Pictures 3** exhibition review, C, Issue No.72

2000
Brayshaw, Christopher, **Mono Maniac** Canadian Art, Vol.17 No. 2

Schwabsky, Barry, **Ron Terada** exhibition review, Art/Text No. 69

Thom, Ian M., **Ron Terada** in Art BC, Vancouver Art Gallery/ Douglas & McIntyre, Vancouver

1999

Beech, Dave, 'East International and Riverside,' *Art Monthly* No.229

Brayshaw, Christopher, 'Dumbed-down TV Talk Emerges as Poetry in Terada's Jeopardy,' *Vancouver Courier*, 14 November

Crawford, Ashley, 'The Biennial's Big Night,' *The Age*, Melbourne, Australia, 13 May

Milroy, Sarah, 'Vancouver Painters Reach Critical Mass,' *The Globe & Mail*, 15 May

Scott, Kitty, 'Cityscape Vancouver,' *Flash Art International*, Vol. 32, No. 206

Scott, Kitty, 'Universal Pictures,' in *Signs of Life: Melbourne International Biennial*, exhibition catalogue, Melbourne

Wallace, Keith, 'The Beauty of Rupture: Artists of Asian Descent and Canadian Identity,' *Art Asia Pacific*, Issue #24

1998

Humeniuk, Greg, 'Ron Terada, Grey Paintings,' *Lola*, No. 3

Knode, Marilu, 'New Vancouver Art: Deliberately Pushy,' *Art/Text* No. 59

Laurence, Robin, 'Slacker-Generation Artists Take Out The Pop Culture Trash,' *Georgia Straight*, 5-12 March

Lum, Ken 'Six New Vancouver Modern,' *Canadian Art*, Vol. 15 No. 2

MacKay, Gillian, 'AGO Show Examines the Art of the Parting Shot,' *The Globe & Mail*, 31 October

Ritchie, Christina, 'Meaningless Thresholds,' in *Present Tense: Ron Terada*, exhibition brochure, Art Gallery of Ontario, Toronto

Watson, Scott, '6: New Vancouver Modern,' in *6: New Vancouver Modern*, exhibition catalogue, Morris & Helen Belkin Art Gallery, UBC, Vancouver

1997

Armstrong, John, 'Masquerade,' exhibition brochure, Mercer Union, Toronto

Brayshaw, Christopher, 'Grey Paintings,' *Vancouver Courier*, 5 March

Shier, Reid, 'Ron Terada: Grey Paintings,' exhibition brochure, Or Gallery, Vancouver

1996

Patten, James, 'Modern Love,' in The Young Contemporaries 96, exhibition catalogue, London Regional Art & Historical Museums, London, Ontario

1995

Hogg, Lucy, 'Mimics,' in Type-Cast, exhibition catalogue, Charles H Scott Gallery, Vancouver

Books by the Artist

2009 *Cockatoo Island*, Bywater Bros. Editions, Toronto and Or Gallery, Vancouver

2003 *Defile*, Art Metropole and YYZ Artists' Outlet, Toronto

Awards

2006 Victor Martyn Lynch-Staunton Award, Canada Council for the Arts, Ottawa

2004 VIVA Award, The Jack & Doris Shadbolt Foundation for the Visual Arts, Vancouver

Residencies

2009 Paul D. Fleck Fellowship, The Banff Centre, Alberta

2004 International Studio & Curatorial Program, New York, Canada Council for the Arts, Ottawa

Collections

Agnes Etherington Art Centre, Queen's University, Kingston, Ontario

Art Gallery of Nova Scotia, Halifax, Nova Scotia

Art Gallery of Ontario, Toronto, Ontario

Ikon Gallery, Birmingham, UK

Morris & Helen Belkin Art Gallery, University of British Columbia, Vancouver, British Columbia

Musée d'art contemporain de Montréal, Quebec

Museum of Contemporary Art, Los Angeles, California

National Gallery of Canada, Ottawa, Ontario

Vancouver Art Gallery, Vancouver, British Columbia

Dan Gra
Time/Pl

CLIFF LAUSON is Curator at the Hayward Gallery, London where he is currently curating an exhibition of work by Ernesto Neto and co-organising a conference on art and pedagogy. He was previously Assistant Curator at Tate Modern where he worked on the exhibitions *Frida Kahlo, Mark Rothko, Per Kirkeby, Seydou Keïta,* and *World as a Stage.* He recently completed his PhD thesis at University College London titled *In Vancouver as Elsewhere: Modernism and the So-Called 'Vancouver School'* and has published in *The Oxford Art Journal, The Fillip Review,* and *Third Text.*

ANNE LOW is a Canadian artist and curator based in London. She is currently the Contemporary Art Project Editor at Phaidon Press where she edited *Vitamin 3-D: New Perspectives in Sculpture and Installation* and the forthcoming volume *Creamier: Contemporary Art in Culture.* She co-curated the recent group exhibition *From the Gathering* (Helen Pitt Gallery, Vancouver, 2009) and co-edited the forthcoming monograph on American filmmaker Mary Ellen Bute (Almanac Press, 2010). Recent writing includes 'Various Small Fires: The Films of Joyce Wieland', (*C Magazine,* 2008).

TOM MCDONOUGH is associate professor of Art History at the State University of New York-Binghamton and an editor at *Grey Room.* His essays have appeared recently in *Artforum, Parkett,* and *Texte zur Kunst,* among other publications, and he is the author of *The Beautiful Language of My Century: Reinventing the Language of Contestation in Postwar France, 1945-68* (MIT Press, 2007). His most recent book is the edited volume, *The Situationists & the City* (Verso, 2010).

Please address all editorial correspondence to *October,* 611 Broadway, #610, New York, NY 10012. We reserve the right to edit letters and responses selected for publication. We review manuscripts of no more than 8,500 words, double-spaced and submitted in duplicate.

Defile

An Art Metropole + YYZ Artists' Outlet Magazine
artmetropole.com + yyzartistsoutlet.org

Ron Terada: The Trading Places Issue
Volume 1 Issue 1 Spring 2003

ACKNOWLEDGEMENTS

It is more than obvious that my work is indebted to others. With the production of this book, I am specifically grateful to the authors whose work and words have developed and informed the issues and efforts with such incisive, generous, interesting, and articulate lucidity. I would like to thank Derek Barnett, the designer of this book, for making it a pleasure. The book was produced on the occasion of an exhibition, proposed and organized by Barbara Fischer, Helen Legg, and Kitty Scott. I am grateful to them for the attentive and open attitude in the production of both.

Ron Terada

Colophon

Ikon Gallery
1 Oozells Square, Brindleyplace,
Birmingham, B1 2HS, UK
http://www.ikon-gallery.co.uk
tel: +44 (0) 121 248 0708
fax: +44 (0) 121 248 0709
email: art@ikon-gallery.co.uk
Registered charity no: 528892

Staff
Matt Andrews	Visitor Assistant
Emma Bowen	Learning Coordinator
James Cangiano	Curator (Learning)
Judith Harry	Deputy Director
Matthew Hogan	IT/ AV Manager
Sudhir Khimji	Finance Coordinator
Mrinal Kundu	Visitor Assistant
Helen Legg	Curator (Off-site)
Alexandra Lockett	Programme Assistant
Emily Luxford	Marketing Assistant
Chris Maggs	Facilities Technician
Sarah McAlister	Exhibitions Coordinator
Penny McConnell	Visitor Assistant
Jane Morrow	Archivist
Michelle Munn	Visitor Assistant
Matt Nightingale	Gallery Facilities Manager
Sarah Oliver	PA/Office Manager
Elizabeth Pearson	Finance Administrator
Kate Pennington-Wilson	Visitor Assistant
Roma Piotrowska	Visitor Assistant
Nigel Prince	Curator (Gallery)
Morgan Quaintance	Inspire Student
Amy Self	Visitor Assistant
Kate Self	Learning Coordinator
Richard Short	Technical and Office Assistant
Rebecca Small	Marketing Manager
Adam Smythe	Eastside Assistant
Philippa Somervell	Ikon Shop Manager
Helen Stallard	Press & PR Consultant
Richard Stokes	Visitor Assistant
Eva Sullivan	Ikon Shop Manager (Maternity Cover)
Edward Wakefield	Ikon Shop Assistant
Jonathan Watkins	Director

Ikon gratefully acknowledges financial assistance from
Arts Council England and Birmingham City Council.

Walter Phillips Gallery
The Banff Centre, 107 Tunnel Mountain Drive,
PO Box 1020, Station 14, Banff, AB, T1L 1H5 Canada
http://www.banffcentre.ca/wpg/
tel: 403 762 6281
fax: 403 762 6659

Staff
Stephanie Kolla	Curatorial Assistant
Mimmo Maiolo	Preparator
Tabitha Minns	Program Assistant
Naomi Potter	Curator
Mikhel Proulx	Preparatorial Work/Study
Charlene Quantz-Wold	Operations Manager
Carmen Schroeder	Preparatorial Work/Study
Ginger Scott	Curatorial Work/Study
Kitty Scott	Director
Leah Turner	Arts Research/Educational Outreach Work/Study

Walter Phillips Gallery gratefully acknowledges financial
assistance from the Canada Council for the Arts,
the Department of Canadian Heritage, and the Alberta
Foundation for the Arts.

Justina M. Barnicke Gallery
Hart House, University of Toronto,
7 Hart House Circle, Toronto, ON, M5S 3H3 Canada
http://www.jmbgallery.ca
tel: 416 978 8398
fax: 416 978 8387
email: jmb.gallery@utoronto.ca

Staff

Stephanie Azzarello	Work/Study
Katie Bethune-Leamen	Exhibition Coordinator
Natalie De Vito	Exhibition & Program Coordinator
Yael Filipovic	Work/Study
Barbara Fischer	Executive Director/Chief Curator
Alexandra Hong	Work/Study
Klara Kovar	Work/Study
Melissa Koziebrocki	Work/Study
Su-Ying Lee	Work/Study
Laura Legge	Intern
Bogdan Luca	Work/Study
Valentine Moreno	Work/Study
Nava Rastegar	Work/Study
Christopher Régimbal	Curatorial Assistant, Research
Denise Ryner	Curatorial Assistant, Permanent Collection
Vinetha Sivathasan	Work/Study
April Steele	Work/Study
Maiko Tanaka	Curator-in-Residence
Mariah Thompson	Intern
Shauna Thompson	Work/Study

Justina M. Barnicke Gallery gratefully acknowledges
financial assistance from Canada Council for the Arts,
Ontario Arts Council and Toronto Arts Council.